THE SISTINE CHAPEL

THE SISTINE CHAPEL
A Biblical Tour

BY CHRISTINE M. PANYARD, PhD

Paulist Press
New York / Mahwah, NJ

Book and caseside design by Jennifer Conlan
Photographs of Sistine Chapel art and photo of sculpture, p. 7, copyright © by Musei Vaticani, Rome, 2013. Used with permission. All rights reserved.
Frontispiece, p. xii: Portrait of Michelangelo with turban, by Giuliano Bugiardini (1475–1554), Casa Buonarroti, Florence, Italy, photo credit: Scala / Art Resource, NY; bas relief, p. 4: *Battle of the Centaurs* by Michelangelo, Casa Buonarroti, Florence, Italy, photo by author.

Library of Congress Cataloging-in-Publication Data

Panyard, Christine M., 1947–
 The Sistine Chapel : a Biblical tour / written by Christine M. Panyard.
 p. cm.
 ISBN 978-0-8091-0593-9 (alk. paper)
 1. Michelangelo Buonarroti, 1475-1564—Criticism and interpretation. 2. Mural painting and decoration, Italian—Vatican City. 3. Mural painting and decoration, Renaissance—Vatican City. 4. Bible. O. T.—Illustrations. 5. Cappella Sistina (Vatican Palace, Vatican City) I. Michelangelo Buonarroti, 1475–1564. II. Title.
 ND623.B9P26 2013
 759.5—dc22

 2010013631

ISBN: 978-0-8091-0593-9 (hardcover)

Published by Paulist Press
997 Macarthur Boulevard
Mahwah, New Jersey 07430

www.paulistpress.com

Printed and bound in the United States of America

The time is surely coming, says the Lord God,
when I will send a famine on the land;
not a famine of bread, or a thirst for water,
but of hearing the words of the Lord

—Amos 8:11

Table of Contents

PREFACE

I made my first visit to Rome in 2004 and could never have predicted how that trip would change my life.

I have always been interested in history. It was my favorite subject in school, and I planned to become a social studies teacher. I took a job as a substitute teacher when I was in college; it was a dreadful experience. I ran out of the classroom and needed to find another career. Psychology fascinated me, so I declared it as my major. I spent the next forty years as a student and practitioner of that science and art. I've worked in public and private clinics and have been a professor at the University of Detroit Mercy for twenty-four years. I've always felt blessed being in this profession. It is a privilege to work with people and to touch people as a psychologist. However, I never lost my fascination for history, and I nurtured the interest with travel.

I took myself to Greece after I finished graduate school and never stopped exploring the world. I've climbed the pyramids of the Egyptians and the Mayans and have walked the Great Wall of China. I don't know why it took me so long to get to Rome. I was thrilled by the Coliseum and the Forum and humbled by the Vatican. I was especially taken with Michelangelo's ceiling in the Sistine Chapel. It spoke to me as it had to millions of pilgrims throughout the years. I could have spent an entire day lying on my back and letting the majesty of the work envelop me. Fortunately for my travel companions, the tour guide whisked us through much too quickly, and I was not able to contemplate the ceiling as desired. But I could not forget the glorious paintings I had beheld.

When I returned home, I began to read about Michelangelo. After all, I am a professor. I study for a

living. I pored over the works of Ross King, William Wallace, and John Addington Symonds. I searched the Internet and Amazon.com. I learned much about the history and politics of the *Pope's Ceiling* and much about the art of frescoes. But my studies left me feeling incomplete. Something was missing. Nowhere could I find the art of Michelangelo together with the scriptures that provided the basis for his work.

So I decided to write this book. *The Sistine Chapel: A Biblical Tour* brings together the paintings from the ceiling of the Sistine Chapel with their foundation in Holy Scripture. A knowledge of scripture helps one to understand Michelangelo's paintings, and his paintings illuminate scripture. They complement each other. They belong together.

My fateful trip to Rome came a little less than five hundred years after Michelangelo began work on the Sistine Chapel, and I finished writing this book almost exactly five hundred years after he first laid brush to ceiling.

Maybe that's why it took so long for me to get to Rome. Four years ago I would never have believed that I would be writing a book about Michelangelo, or how many times I would return to Rome, or that I would know Florence well enough to give directions to Japanese tourists. My trips to Italy have become part treasure hunt, part retreat, and part pilgrimage.

This has been an exciting journey. It has also been scary; change is both. I've spent many years working with the psychological pain and distress of others. Now I work with spirit and beauty. I trust that God will tell me what he wants from me next, and that angels will guide me. *The Sistine Chapel* is a "thank you" to Michelangelo for helping me along my journey.

Acknowledgments

*P*ublishing is a team sport, and I would like to thank everyone who has played a part in this project. I want to thank Nancy Yount, Pastor David Jahn, and my brother James Panyard, the first people I dared to tell about my growing obsession. Thank you for supporting me and for not rolling your eyes in the dismissive manner I encountered elsewhere. Thank you J. Curtis Russell and Susan Wainstock, my friends from the University of Detroit Mercy, for reading the drafts of my book proposal and walking with me every step of this journey.

Thank you to my editors Jennifer Conlan and Gerry Goggins at Ambassador Books for championing my proposal to Paulist Press. Thank you to Paulist Press for being brave enough to take a chance on this book after forty-nine other publishers passed on the project. And most of all, thank you to Alfred Panyard, my father, for always telling me that I could accomplish anything to which I set my mind. Thank you for helping me to be a little less ordinary and encouraging me to follow the beat of a different drummer.

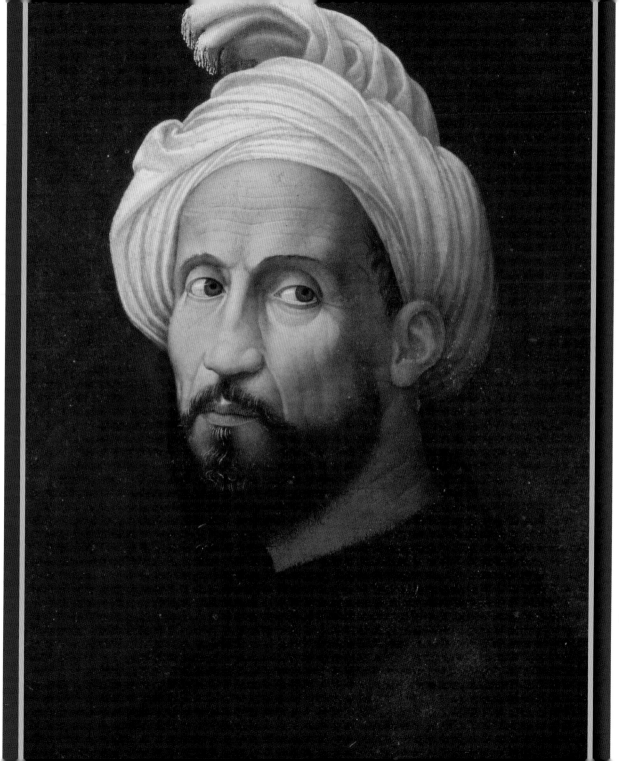

Michelangelo by Giuliano Bugiardini

INTRODUCTION

On May 10, 1508, Michelangelo signed a contract with Pope Julius II to begin work on the ceiling of the Sistine Chapel. It took him more than four years to complete the ceiling. He could not have predicted the impact that commission would have on the world. For five hundred years it has served as an inspiration for the College of Cardinals as they elect popes, as a school for aspiring artists, and as a spiritual beacon. Millions of visitors have walked beneath his glorious paintings. *The Sistine Chapel: A Biblical Tour* was written to pay homage to the endurance of his monumental accomplishment and to teach today's pilgrims how to use his work to help them along their spiritual journey.

The Sistine Chapel has an importance in the history of Western civilization well beyond its size and location. It is the place where cardinals, the princes of the Roman Catholic Church, gather to elect popes. Popes wielded considerable temporal power in the past, and the choices made to succeed St. Peter have helped to shape the world. The one billion Roman Catholic believers of today make the role of the pope significant in our secular world, as well.

But beyond its importance in world politics and spiritual matters, the Sistine Chapel is celebrated for housing one of the world's greatest collections of art. The paintings below Michelangelo's were done by the *Who's Who* of the Renaissance, the floors are covered with beautiful mosaics, and Raphael designed the tapestries that hung below those paintings, now in their own room in the Vatican Museum.

The mosaic floor, reminiscent of medieval work, guides the pilgrim toward the altar and Michelangelo's awesome fresco *The Last Judgment*. Visitors to the Sistine Chapel are overwhelmed by the variety, quality, and power of the works contained in this small space. It is a gallery of the best of Renaissance art. Every painting is a masterpiece.

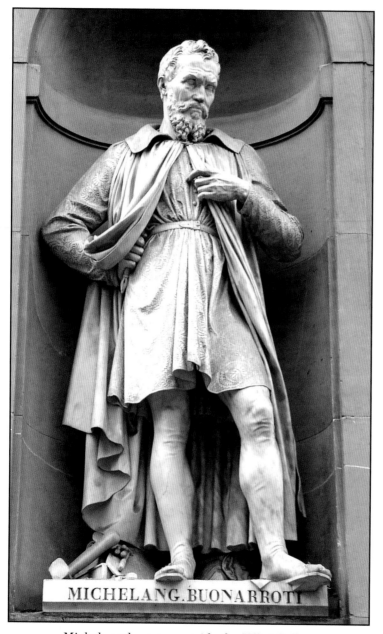

Michelangelo statue outside the Uffizi Gallery

We think of the Sistine Chapel as being a product of the Renaissance, but it was built during the Middle Ages. The chapel was located just to the north of the old St. Peter's Basilica built by Constantine, the first Christian Roman Emperor. It was known as the *capella papalis*, or Papal Chapel. At that time, *Papal Chapel* did not just refer to a building, but also to a group of people which included the pope and approximately two hundred high-ranking members of the church and civil bureaucracy who met there to celebrate Mass on a regular basis. But the land on which the chapel was built was not stable and the building began to shift and deteriorate. The first document relating to its existence was written in 1368 and described the chapel as an irregular building in need of repair.

Pope Sixtus IV (Francesco della Rovere 1471–1484) decided to rebuild the chapel as part of his program to beautify Rome and immortalize his papacy. The chapel was named the Sistine Chapel in his honor. He contracted Baccio Pontelli, a Florentine architect, to begin work in 1477.

Pontelli was a military architect, and the chapel was to have defensive as well as spiritual features. Pope Sixtus engaged in military skirmishes with other city-states on the Italian peninsula and felt that he needed more than spiritual protection. The original structure was not destroyed, and the lower

third was kept as the base for the new chapel. Pontelli designed the chapel to conform to the dimensions of the Temple of Solomon in Jerusalem. It was 130 feet long, forty-three feet wide, and sixty-five feet high. The walls at the base were ten feet thick and were topped with a walkway for sentinels. The structure was designed to allow archers to shoot arrows and for boiling oil to be poured on attackers if needed. Above the vault were rooms that housed soldiers and, later, prisoners.

The greatest painters in Florence were hired to paint frescoes on the walls of the Sistine Chapel. They included Pietro Perugino, Sandro Botticelli, Cosimo Rosselli, Piero di Cosimo, Domenico Ghirlandaio, and Luca Signorelli.

There were originally five paintings on each side of the chapel and two on the wall behind the altar representing the lives of Moses and Christ. (The two paintings behind the altar were later destroyed to make room for Michelangelo's *The Last Judgment*.) Full-length portraits of previous popes were painted in the niches between the arched windows above the frescoes. The ceiling was painted by Pier Matteo d'Amelia. He painted a deep blue sky with gold stars, a common form of decoration at that time.

The frescoes were remarkably similar in style and palette. This reflects the fact that artists during the Renaissance were considered craftsmen just like carpenters or stonemasons. They were hired to complete a specific job. Art was not the expression of the artist's unique view of the world but a product requested by the patron.

Pope Sixtus IV dedicated the chapel to Our Lady of the Assumption on August 15, 1483. His nephew, Cardinal Giuliano della Rovere, would become Pope Julius II (1503–1513) and continue to beautify the chapel.

∞

Pope Julius II did not commission Michelangelo to paint the ceiling in the Sistine Chapel solely to honor his uncle, Pope Sixtus IV. By 1504 the chapel was twenty-one years old and significant damage had occurred. The foundation beneath the chapel continued to shift, and it became a dangerous place; the chapel was actually closed for several months because of the danger. A new architect, Giuliano da Sangallo, placed iron bars in the vault and the floor to stop the shifting. D'Amelia's heavenly ceiling had been damaged to such an extent that major repairs were required and the new brickwork and plaster required to repair it left d'Amelia's fresco scarred. Pope Julius II probably began discussions with his chief architect, Donato Bramante, to repaint the ceiling early in his papacy. Some historians think that Bramante had a role in selecting Michelangelo for the job. Not that he was any friend to Michelangelo; Bramante knew that Michelangelo had little experience working in fresco and may have championed Michelangelo so that the renowned artist would have an opportunity to fail.

∞

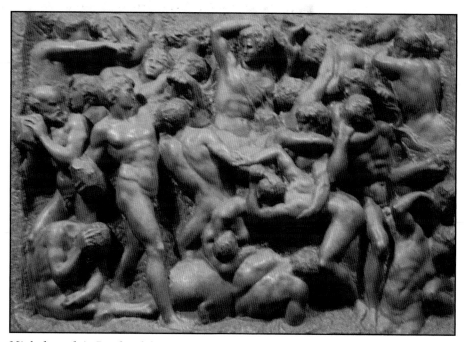

Michelangelo's *Battle of the Centaurs*, Casa Buonarotti, Florence, Italy.

The Florentines were excited about this competition between the greatest artists of the day. However, neither the painting by Michelangelo nor the one by Leonardo da Vinci was completed.

Michelangelo completed many preparatory drawings for the *Battle of Cascina*, including the large cartoon used to transfer the drawing to the wall. (Artists working in fresco made detailed drawings on huge pieces of paper that were pricked or incised and used as stencils.) Michelangelo did not paint the typical battle scene with soldiers engaging in combat; he chose to portray soldiers at a moment of rest, bathing in the Arno River. Someone alerts the soldiers to the approach of the Pisan army, and they scramble to get out of the river and to prepare for battle.

This theme allowed Michelangelo to create many variations of the male nude. The cartoon for the *Battle of Cascina* was completed and displayed to the public. It was much admired and copied by other artists. Although Michelangelo's cartoon for the *Battle of Cascina* no longer exists, it was similar to the sculpture the *Battle of the Centaurs* completed in 1492. The bas relief, now in the Casa Buonarotti, was an early sign of Michelangelo's interest in the nude male body, an inter-

Michelangelo probably learned how to fresco while working as an apprentice in the workshop of Domenico Ghirlandaio. But he saw himself as a sculptor and did very little painting prior to the Sistine Chapel. Because of his great success as a sculptor, he was commissioned by the governing body of the city of Florence to fresco a wall in the Hall of Five Hundred in the Palazzo della Signoria in 1504. The Hall of Five Hundred was the meeting place for the Council of the Republic. Michelangelo was to commemorate the Battle of Cascina won against the Pisan army in 1364. Leonardo da Vinci was to paint a battle scene on the opposite wall.

est that would be expressed many times over in his sculptures and paintings, including the Sistine Chapel.

Michelangelo's work in Florence was interrupted when Pope Julius II called him to Rome in 1505. Pope Julius, the Warrior Pope, intended to reconstruct St. Peter's Basilica, which was one thousand years old and deteriorating. He wanted to create a magnificent tomb within the basilica to house his own remains. Michelangelo was to create a monumental structure with many individual statues. Because he saw himself primarily as a sculptor, he was more than happy to leave the fresco in Florence for such an opportunity.

Michelangelo spent eight months in the marble quarries of Carrara, Italy, overseeing the selection and transportation of large pieces of stone. During that time he designed some of the equipment used to transport the huge blocks of marble out of the quarries and into Rome. He also began to work on preparatory drawings. Michelangelo was in his element and described that time as one of the happiest of his life. However, his sojourn to Carrara removed him from the politics of the papal court and the changing political scene.

By the time Michelangelo returned to Rome, Pope Julius II was more concerned with retaking the papal states than building his tomb. It has also been suggested that Donato Bramante, the architect of the new basilica, was plotting to turn the pope's favor from Michelangelo. Whatever the reason, Michelangelo no longer had the ear of the pope and no longer had support for building the tomb. He returned to Florence in April 1506 both angry at his fall from favor and, some historians contend, fearful that his life might be taken in some nefarious plot. The tomb remained unfinished for forty years.

୫୨

Pope Julius II waged a successful campaign to recapture the papal states and rode into Bologna victorious in November, 1506. He summoned Michelangelo from Florence and offered him a new commission. Michelangelo was to build a monumental bronze statue of the Warrior Pope.

Michelangelo worked diligently in this new medium and mastered the art of working with bronze as he had mastered all other media. The statue was completed but was destroyed in 1511 when it was melted down to make a cannon. It was referred to as La Giulia, in memory of the Warrior Pope.

In the spring of 1508, Pope Julius II once again called Michelangelo to Rome, this time to begin work on the ceiling of the Sistine Chapel. The popular image is that Michelangelo was a grizzled old man suffering from the stress of his craft. In reality, he was only 33 years old when he began working on the ceiling. Michelangelo was reluctant to accept the commission. He is said to have responded, "*Non e mia arte.*" It is not my art.

The ceiling covered approximately 5,700 square feet. An undertaking of such magnitude would have been a daunting task for an experienced fresco artist, let alone one unaccustomed to this medium. Condivi, a

friend and biographer of Michelangelo, reported that Michelangelo initially recommended Raphael Sanzi for the job. Despite such misgivings, however, Michelangelo signed a contract with the pope on May 10, 1508, to begin what would become the most celebrated collection of paintings in the world.

<center>৪৫</center>

*M*ay 10, 1508, is sometimes also given as the date when Michelangelo began painting the ceiling of the Sistine Chapel, but he probably did not begin until August at the earliest. There was much to be done before he could lay brushes to the ceiling. Bramante, the pope's architect, supplied scaffolding suspended from the ceiling. It would have been impossible to paint the holes where the ropes were attached. Michelangelo complained to the pope, who decided to let him design his own scaffold. He designed one that could be moved down the chapel as the work was completed. It was affixed to the walls of the chapel by means of poles inserted in the walls. The holes were discovered during the 1980–1990 cleaning and restoration of the ceiling. The scaffold provided ample room for a crew to stand while they worked on the ceiling. The chapel was to continue to function as a place of worship during the painting, so a tarp was hung on the underside of the scaffold. This prevented paint from dripping on the floor of the chapel and also kept Michelangelo's work a secret until he was ready to unveil it.

It is a Hollywood myth that Michelangelo completed the ceiling alone and lying on his back. Michelangelo hired assistants for this monumental work. There is evidence that he had a crew of at least thirteen, some of them, painters he knew from Florence. His assistants would help with the construction of the scaffold, removal of the old plaster, mixing and applying plaster daily, preparing paints and brushes, transferring cartoons to the ceiling, and painting architectural details. And then, of course, Michelangelo needed to design the ceiling.

There is little to document who was involved in the design of the ceiling. It would be wrong to assume that Michelangelo was given permission to paint as he pleased. Renaissance artists were craftsmen who worked at the pleasure of their patrons. They were not free spirits who worked for their own pleasure and hoped to find customers for their work. Pope Julius II gave Michelangelo a plan that included the twelve apostles and geometric designs for the ceiling. The pope's theologians, Cardinal Alidosi and Prior General of the Augustinian Order, Egidio Antonini were probably involved.

Michelangelo began making preparatory drawings to fulfill the pope's vision. But he was dissatisfied and told the pope that his proposal would prove a *cosa povera* (poor thing). Michelangelo felt that the apostles, all poor men, were not grand enough images for so great a chapel. He discussed this with the pope and wrote, "He gave me a new commission to do what I liked." Despite what Michelangelo wrote, the final design would need approval from the pope's official theologian, the *haereticae pravitatis inquisitor*, master of the sacred palace. At the

time Michelangelo began work on the ceiling, a Dominican friar by the name of Giovanni Rafanelli held that position. Michelangelo wrote letters to his family on a regular basis and nowhere was there evidence about disagreements over the plan for the ceiling. Apparently the working relationship between Michelangelo and the pope's theologians was satisfactory to all.

∞

*D*espite the structure imposed on this project by the pope and his theologians, Michelangelo was able to bring his experience, education, and spiritual nature to his work. After his apprenticeship to Ghirlandaio, where he was exposed to fresco techniques, he moved to the home of Lorenzo de' Medici, living as a member of the family from 1489 until 1492, when Lorenzo the Magnificent died. During that time he worked in the sculpture gardens at San Marco. More important, he was exposed to the greatest humanists of the day who frequented the Medici court. Michelangelo was an educated man and was reported to have memorized all of Dante's *Divine Comedy*. He knew the Bible well and was influenced by the fire and brimstone preacher Savonarola. Michelangelo was also a student of classical and contemporary art. He had the opportunity to study the *Laocoon Group* and the *Belvedere Torso*, both now housed in the

Vatican Museums. He also studied the frescoes of Masaccio in the Brancacci Chapel, the sculptures of Jacopo della Quercia in Bologna, the frescoes of Luca Signorelli in the Cathedral at Orvieto, and Ghirberti's brass doors on the Baptistery in Florence.

Renaissance humanism championed the dignity of the individual. Artists had moved away from the stereotypic images of Byzantine art to a regard for the dignity of each individual. Renaissance paintings offered realistic images rather than stylistic caricatures. Man was made in the image of God and therefore was the supreme repre-

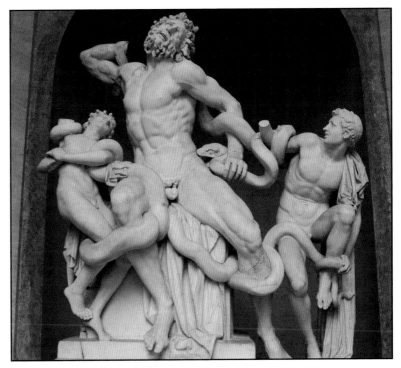

Laocoon Group, Octagonal Courtyard, Vatican Museum

sentation of beauty. The male adolescent was considered the most perfect of human forms.

Michelangelo used the human body to tell his stories. His anatomical studies as well as his studies of classical sculpture helped him to perfect the realism of his compositions. His respect for the value of the individual is reflected in the lack of repetition in the poses, emotions, and physical characteristics of his subjects. Given that there were over three hundred figures in the ceiling, this was truly a remarkable accomplishment and a testament to the impact of Renaissance philosophy on his work.

Michaelangelo also brought great expertise to this fresco work. The term fresco comes from the Italian *buon fresco*, which means good fresh plaster. The first step in working in this medium is to cover the entire ceiling with a new coat of plaster called *arricio*. Then *intonaco*, a very smooth plaster, is applied. The *intonaco* was prepared every day and only in the amount needed for that day's work. One day's work was called a *giornate*. (During the restoration, it was determined how many days were taken to paint each section of the ceiling by counting the points at which each *giornate* touched.) The *intonaco* would be applied to the section of the ceiling that Michelangelo wanted to work on. He would wait until it was at the right point of dryness and then transfer the cartoon to the ceiling. After the car-

toon was transferred to the ceiling, he could begin to paint. Michelangelo needed to work quickly and complete the day's work before the ceiling was too dry. If he waited too long, the pigments would not fuse with the plaster. Pigments done *al secco*, or dry, remain on top of the plaster, making them more likely to flake off, and the image deteriorates more quickly. The correct use of this technique guarantees that the paints will become fused with the wall and become incredibly durable. It is a testament to Michelangelo's understanding of the science of fresco that his work has lasted for five hundred years.

Michelangelo's grand scheme of salvation included nine stories from the Book of Genesis, four stories of the redemption of the Jewish people, twelve prophets and sibyls who foretold the coming of Christ, twenty-four lunettes and pendentives describing the ancestors of Christ, and twenty male nudes with ten medallions representing stories from the Old Testament.

The *medallions* have received little attention from art historians. Most mention their existence, but do not spend much time describing them. There is good reason for what could be considered an oversight. The medallions are very small, only four feet in diameter. They are done in tones of bronze and are very difficult to read from the chapel floor. They were painted by

The medallion *Alexander the Great before the High Priest of Jerusalem*

Michelangelo's assistants, not the master. He probably gave them sketches and they painted the medallions freehand. There were no cartoons done to guide their work. Bastiano da Sangallo has even been credited with the complete design and execution of one. Much of the work on the medallions was done *a secco*, which means on a dry surface. The tints did not fuse with the plaster and deteriorated much faster than the rest of the ceiling. They are even more difficult to see today than when they were first painted.

The medallions are not consistent with the theological plan of the ceiling. It must be remembered that art in the Renaissance was not done solely to illustrate religious themes, but also to make political statements. The medallions are about warrior priests and battles to subjugate wayward people. They were meant to demonstrate the divine backing Pope Julius II had for his military excursions to return territories in the Papal States to submission to the pope. In one medallion, *Alexander the Great before the High Priest of Jerusalem*, the high priest wears a papal tiara that clearly signifies that the authority of the pope is greater than that of temporal leaders.

Only two medallions are related to the theological plan of the ceiling. The medallions nearest the altar are *Abraham's Sacrifice of Isaac* and *Ascension of Elijah*. These relate thematically to the sacrifice and ascension of God the Father's son, Jesus Christ.

The *sibyls* sit on marble thrones, accompanied by divine assistants, and are seen with books and scrolls that are indicative of their scholarly work. The sibyls were wise women from antiquity and it was thought that their words also foretold the coming of Christ. They alternate with the prophets from the Old Testament and are painted the same size as their biblical counterparts. This spoke to how highly the works of the sibyls were regarded during the Renaissance. The pictures are striking and powerful. Michelangelo did not have much experience with women and his figures have a very masculine appearance. John Addington Symonds wrote, "The defect of his art is due to a certain constitutional callousness, a want of sensuous or

Cumæan Sybil

Plan of the Sistine Chapel

BOOK OF GENESIS
1. The Separation of Light from Darkness
2. Separation of the Earth from the Waters
3. Creation of Plants and the Sun and Moon
4. The Creation of Adam
5. The Creation of Eve
6. The Temptation and Fall of Adam and Eve
7. The Deluge
8. The Sacrifice of Noah
9. The Drunkenness of Noah

STORIES FROM THE OLD TESTAMENT
10. David and Goliath
11. Judith and Holofernes
12. The Punishment of Haman
13. The Bronze Serpent

PROPHETS OF ISREAL
14. Zechariah
15. Joel
16. Isaiah

17. Ezekiel
18. Daniel
19. Jeremiah
20. Jonah

SIBYLS
21. Delphic Sibyl
22. Erythræan Sibyl
23. Cumæan Sibyl
24. Persian Sibyl
25. Libyan Sibyl

GENEALOGY OF JESUS
26. Aminadab
27. Nahshon
28-29. Salmon, Boaz, and Obed
30-31. Jesse, David, and Solomon
32-33. Rehoboam and Abijah
34-35. Asa, Jehoshaphat, and Jehoram
36-37. Uzziah, Jotham, and Ahaz
38-39. Hezekiah, Manasseh, and Amon

40-41. Josiah, Jechoniah, and Shealtiel
42-43. Zerubbabel, Abiud, and Eliakim
44. Azor and Zadok
45. Achim and Eluid
46. Eleazar and Matthan
47. Jacob and Joseph

MEDALLIONS
48. Death of Razis
49. Expulsion of Heliodorus
50. Alexander the Great before the High Priest of Jesusalem
51. Death of Absolom
52. Abraham's Sacrifice of Isaac
53. Ascension of Elijah
54. Elisha Cures Naaman of Leprosy
55. Death of Nicanor
56. Mattathias Pulls Down the Altar in Modein
57. Antiochus Epiphanes Falls from His Chariot

imaginative sensibility for what is specifically feminine" (Vol I, p. 267). Michelangelo's anatomical studies were done on men and, as a homosexual, he had little direct experience with women's bodies. Male models were used for many of the preparatory studies for the sibyls. The paintings were subsequently given female attributes but still did not reflect feminine characteristics. The sibyls are not featured in this book because they are not found in the Bible and this book is based on the scriptural referents of Michelangelo's work.

Architectural details were used to provide a framework for the more than three hundred figures in seventy-nine separate scenes. Arches, cornices, plinths, colonnettes, thrones, and seats were painted to resemble real architectural features. Symmetrical pairs of *putti*, small angelic figures, held up the cornices on either side of the thrones of the prophets and sibyls. Their neutral color made them look more like sculpture than fresco. Small bronze nudes were painted in the nooks around the ancestors of Christ. The stories from the Book of Genesis were told on the central spine of the ceiling and the large figures of the prophets and sibyls below Genesis. The ancestors of Christ occupied the lunettes surrounding the tops of the windows in the chapel. The stories of the Jewish people were told in the large spandrels in the corners of the ceiling. (A spandrel is the space between two arches or between an arch and an adjacent wall.)

&

Michelangelo began near the entrance wall and worked his way toward the altar. Nine ceiling panels were used to tell the stories from the Book of Genesis. Three were devoted to each of the stories of Noah, Adam and Eve, and Creation. He alternated five small and four large panels for this section. The small panels were framed by large *ignudi*, or nudes, who held bronze medallions. They have been called "Christian athletes" and "wingless angels." The *ignudi* were not part of the stories they framed, so it is difficult for visitors to understand why they were included in the first place.

The nudes were painted in different poses with different facial expressions. They have become a catalog for young artists learning to draw the human figure. The *ignudi* may also have been a way for the sculptor, Michelangelo, to stay connected to his preferred form of artistic expression. The nudes hold large bronze medallions with stories from the Old Testament. The stories concern temporal power and obedience to authority and suggest the pope's influence in determining their content. The largest panels are used for the stories of greatest significance. For example, in the story of Noah, the Deluge (the Flood) is given the greatest amount of space. However, this means that some of the panels are out of historical sequence. The entire central spine of the ceiling is a backwards theology that goes from *The Drunkeness of Noah* toward *The Separation of Light from Darkness*. *The Separation of Light from Darkness* comes before the story of Noah in the Bible, but it is the last scene the visitor walks under as

he approaches the altar. The visitor moves from the sacrifice of Noah to the sacrifice of Christ, from the sinfulness of man to redemption and renewal at the cross.

The Deluge was the first story to be painted. It is significant because of the number of figures in it. Michelangelo painted more than sixty people attempting to save themselves from the rising waters. In order to get that many people into one panel, they had to be fairly small. When the first half of the ceiling was unveiled, Michelangelo recognized that they would be difficult to see from the floor and made the subsequent panels less complex. He told the rest of the stories with fewer, larger figures. This also reduced the time needed to complete the ceiling and satisfied Pope Julius II, who kept pressuring him to finish more quickly.

Michelangelo painted the prophets and sibyls, ancestors of Christ, and the stories of David and Goliath and Judith and Holofernes, then moved the scaffold toward the altar and continued his work.

The first half of the vault was unveiled on August 15, 1510, twenty-seven years after Pope Sixtus IV consecrated the chapel to Our Lady of the Assumption. It was a great event that was hailed by clergy and artists alike. After a brief trip home to Florence, Michelangelo rebuilt the scaffold and began work on the second half of the Sistine Chapel. The completed chapel was unveiled on the Eve of All Saints Day, October 31, 1512. In a letter to his father, Michelangelo wrote, "I have finished the chapel I have been painting. The Pope is very well satisfied." Pope Julius II, Michelangelo's patron and protagonist, died just a few months later on February 21, 1513.

Michelangelo hoped to return to his work on the tomb for Pope Julius II after he completed the ceiling in the Sistine Chapel. That was not to be. After Pope Julius II died, the contract with the Della Rovere family was rewritten several times and a much smaller tomb was completed in 1545 for San Pietro in Vincoli. The Medici popes, Leo X and Clement VII, would control the Vatican and its patronage from 1513–1534. (Hadrian VI, a Dutch, reform-minded pope, would sit on the chair of St. Peter for only one year between the two cousins.) The Medici popes were great patrons of the arts, but wanted Michelangelo's talents used to enhance the reputation of their family rather than the Church. Michelangelo spent the next twenty-three years working on the Medici Chapel, the Laurentian Library and other projects in Florence.

Alessandro Farnese was elected Pope Paul III in 1534 and called Michelangelo back to Rome. Michelangelo left many works unfinished in his studio in Florence and spent the remaining thirty years of his life in Rome. Pope Paul III had plenty for him to do, including the Campidoglio, the dome of St. Peter's, the Farnese Palace, frescoes of Saints Peter and Paul in the pope's private chapel, and *The Last Judgment* fresco in the Sistine Chapel.

∞

*T*he impact of Michelangelo's ceiling in the Sistine Chapel on the world of art was immense and imme-

diate. Vasari, a friend and biographer, wrote, "This work has been and truly is the beacon of our art, and it has brought such benefit and enlightenment to the art of painting that it was sufficient to illuminate a world which for so many hundreds of years had remained in the state of darkness."

Raphael, who had been working on frescos in the Stanza della Segnatura of the Vatican, was so impressed that he attempted to secure the commission for the second half of the chapel. He realized not only the greatness of the work, but the size of the audience that would come to admire it. His work in the private apartments of the pope would never receive the acclaim of Michelangelo's ceiling. Pope Julius II did not give in to the requests of Bramante and Raphael and allowed Michelangelo to complete the ceiling.

Raphael had completed a large fresco in the pope's apartments called the *School of Athens*. It included figures of the greatest scholars and philosophers of antiquity. After seeing the first half of the Sistine Chapel ceiling, he honored Michelangelo by adding him as the philosopher Heraclitus of Ephesus. Raphael was known for being able to incorporate the style of other masters into his own work. In his *Expulsion of Heliodorus from the Temple*, painted in the room next to the Stanza della Segnatura in 1512, the figures show much more vitality and action than in his previous frescoes. The musculature and movement of his figures is a reflection of the influence of Michelangelo's work.

The ceiling of the Sistine Chapel has been a school for artists for hundreds of years. Sketches and engravings done of Michelangelo's figures shortly after the first half of the ceiling was unveiled became catalogs that other artists would use to design their own compositions. Contemporary artists influenced by Michelangelo included Rosso Fiorentino, Jacopo da Pontormo, and Titian. Sir Joshua Reynolds, a renowned English painter, copied Michelangelo's work in 1750. He described the work as "the language of the Gods," and urged all aspiring artists to do the same. Camille Pissarro, Peter Paul Reubens, and William Blake all worked from the ceiling of the Sistine Chapel. August Rodin studied in Italy, and it is said that *The Prophet Jeremiah* influenced his sculpture *The Thinker*. Diego Rivera, the renowned muralist from Mexico, studied Italian frescoes in the 1920s. Michelangelo's influence can be seen in the muscular assembly-line workers in Rivera's murals in the Detroit Institute of Arts. Michelangelo's work continues to be a must-see for any serious student of art.

෨෬

The Sistine Chapel plays an important role in the Roman Catholic Church. It is the place where the Sacred College of Cardinals meets to elect a new pope. *Cardinal* comes from the Latin *cardo*, which means hinge. The cardinals hold the Church together. Pope Celestine IV (1241–1241) was the first pope elected by a true conclave, a private, cloistered meeting of the cardinals. The cardinals at that time were taking an exceedingly long time to elect a new pope, so they were locked in the Sep-

tizonium Palace on the Palatine Hill until they reached a decision. They were cloistered for several weeks in terrible unsanitary conditions. Several cardinals became sick and one died as a result. Pope Celestine IV's papacy lasted only seventeen days.

The habit of *cloistering,* or isolating, cardinals during a conclave continued in the Sistine Chapel. Partitions were brought in to form monastery-like cells where the cardinals slept. They were assigned to the cells randomly, and it was considered good luck to be assigned near Perugino and Signorelli's fresco *The Consignment of the Keys to the Kingdom.*

The Sacred College of Cardinals continues to meet in secrecy in the Sistine Chapel to elect a pope. The secrecy and isolation are to reduce the influence of outside forces on their decision making. However, the cardinals no longer live in the chapel. During the early conclaves, thousands of candles were lit to illuminate the ceiling. It was hoped that Michelangelo's images would inspire the cardinals below. The candlelight helped the cardinals in their work but also contributed to the deterioration of the frescoes.

The results of the election are still communicated with colored smoke to the faithful who wait in St. Peter's Square. Black smoke indicates that a decision has not been made and white smoke indicates that the Church has a new pope.

❧

The impact of Michelangelo's ceiling of the Sistine Chapel goes far beyond art and the Church. His images of God have become part of the collective unconscious of Western man. When we think of God, Michelangelo's paintings of an older man with long white hair and a beard, wearing flowing robes, is the most likely image to come to mind. And yet nowhere in the Bible is that description of God to be found. Quite the contrary, Moses is told, "You cannot see my face, for no one shall see me and live" (Exod 33:20).

Michelangelo filled a huge hole in Christian iconography with his image of God the Father. His image of a powerful God reaching out to give life to a languid man is also iconic. The fingers of God and Adam are recognized by most people as representing the creation of man. The strength of these images in our consciousness is demonstrated by the numerous times they have been parodied and used in advertising and other graphic arts.

❧

Michelangelo's frescoes began to deteriorate before he had completed the ceiling. At first he thought this would be a good excuse for him to discontinue the commission. But Pope Julius II sent Giulianno da Sangallo to help. He discovered the plaster was too wet and that contributed to the decay. Michelangelo changed the mixture and continued painting. The first major restoration began in 1568 when Domenico Cannevali was sent

to repaint areas where the *intonaco* had fallen off. But Michelangelo's work survived despite the fundamental weakness of the chapel's foundation, rainwater seepage, the candle soot and incense from five hundred years of religious services, attempts at restoration, an explosion at Castel Sant'Angelo, and 17,000 daily visitors.

The last major restoration of the Sistine Chapel began in 1965 under the direction of the Vatican's Laboratory for Restoration of Pictures. The restoration began with the fifteenth-century frescoes on the walls of the chapel and moved up the chapel walls to the frescoes of the popes. In 1980, work began on Michelangelo's ceiling. The work was sponsored and documented by a Japanese television company, NTV, and supervised by Gianluigi Colalucci. Colalucci described the project more as a "patient cleaning" than a restoration.

Centuries of soot, grime, and animal glues were painstakingly removed. Bronze tacks, which were used to hold the *intonaco* in place, were replaced with brads that would not corrode. Chemical analyses of the surface were conducted to determine how to clean the fresco without damaging it and to determine what parts were the work of Michelangelo and what parts had been restored by other artists. At the same time, a climate control system and low heat lights were installed to prevent future damage. The restoration took ten years, more than twice as long as it took Michelangelo to paint the ceiling.

The results of the "patient cleaning" were startling. Some had considered the dark colors of the ceiling before the restoration to reflect the morose, tortured soul of Michelangelo. Some critics opposed the cleaning on the grounds that Michelangelo intended the colors to be degraded by soot and candle smoke. But the restoration revealed that Michelangelo had used brilliant colors. The vibrancy of the colors astonished observers and enlivened the figures. The ceiling was returned to the glory described by Vasari who said, "It was sufficient to illuminate a world which for so many hundreds of years had remained in the state of darkness."

❦

*M*illions of pilgrims have walked beneath the Sistine Chapel's ceiling in the past five hundred years. Tour guides usher their groups through in twenty minutes leaving visitors awed by the power of Michelangelo's work and overwhelmed by the magnitude of his achievement. There is just too much happening on the ceiling to comprehend in one short visit. A better understanding and appreciation of the grandeur of Michelangelo's accomplishment can only be attained through repeated visits. Books provide the opportunity to reflect on the images when return trips to the Sistine Chapel are not possible. *The Sistine Chapel: A Biblical Tour* is intended to help the visitor and nonvisitor alike to gain a deeper spiritual and aesthetic appreciation of Michelangelo's masterpiece, which after a half millenium remains one of the greatest wonders of the world of art.

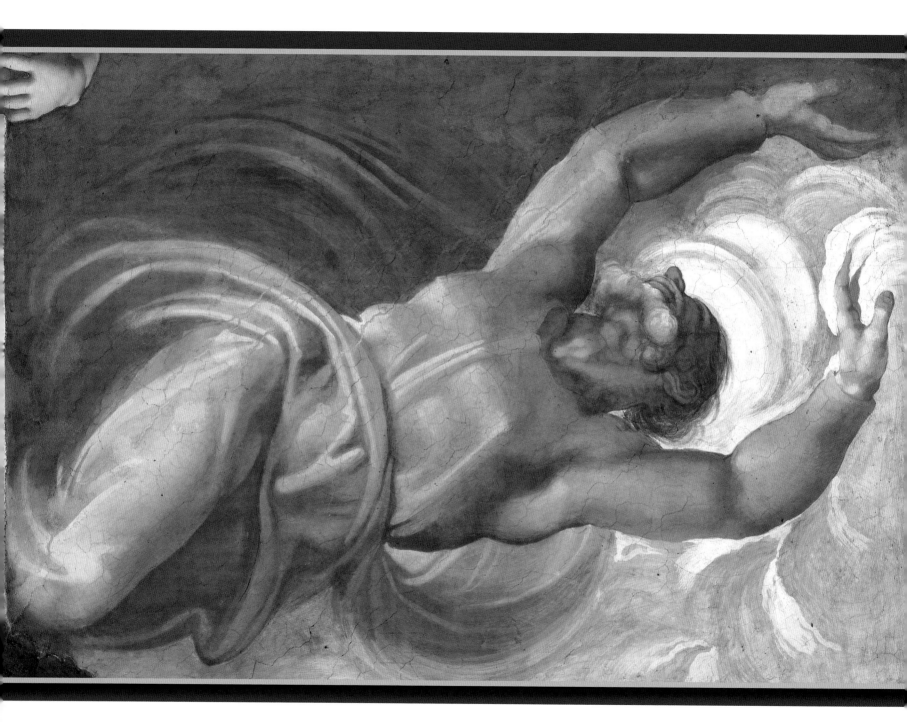

THE SEPARATION OF LIGHT FROM DARKNESS

Then God said, "Let there be light"; and there was light. And God saw that the light was good; and God separated the light from the darkness. God called the light Day, and the darkness he called Night. And there was evening and there was morning, the first day.

—Genesis 1:3–5

The Separation of Light from Darkness is the first story in the Book of Genesis, but the last story visitors see as they approach the altar. It is also the last one Michelangelo painted. This painting is a testament to how much he learned during the four years it took to complete the ceiling of the Sistine Chapel.

God is seen from below. It is as if he is whirling and spinning right above our heads. We can almost feel the energy it took to separate light from darkness. But all we can see is the underside of his face, neck, and torso. God had never been painted from this angle before. The Separation of Light from Darkness is more than just a picture. The visitor feels as if he is really standing beneath God and looking up at him. Most of Michelangelo's figures were drawn from life. But no model could have held this position. The image sprang from his genius and demonstrates his skill in the use of perspective.

Michelangelo's mastery of the technique of painting frescoes is evident in this work. His first work, The Deluge, took twenty-nine days to complete, yet The Separation of Light from Darkness was completed in just one day. Michelangelo painted it very quickly and without the use of cartoons or stencils. The image went directly from his vision to the ceiling, a truly remarkable feat.

The placement of this fresco is significant. It is directly over the altar, over the cross. This represents the oneness of God the Father and Jesus Christ his son. It says very clearly that Christ, like the Father, is eternal. They have always been together, and therefore were painted together in the Sistine Chapel.

The separation of light from darkness represents the separation of good from evil and, on Judgment Day, the saved from the damned. Michelangelo began painting The Last Judgment, his monumental work about the end of times, on the altar wall twenty-four years after completing the ceiling. He may never have thought that he would work in the Sistine Chapel again. Yet, his final fresco completes the story of mankind perfectly.

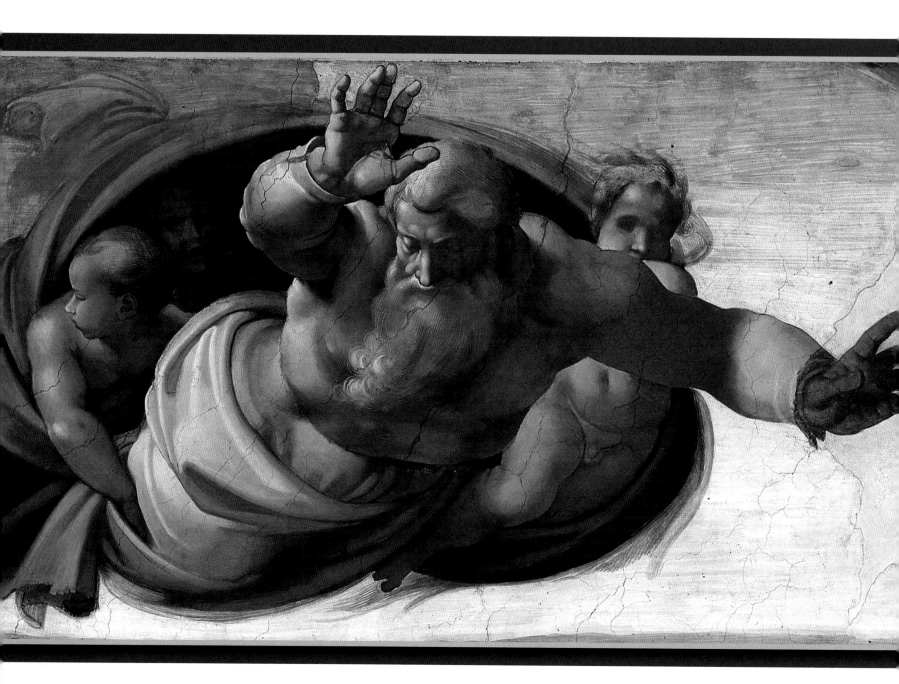

SEPARATION OF THE EARTH FROM THE WATERS

And God said, "Let the waters under the heavens be gathered together into one place, and let the dry land appear." And it was so. God called the dry land Earth, and the waters that were gathered together he called Seas. And God saw that it was good.

—**Genesis 1:9–10**

Michelangelo created a completely new image of God. There is no description of what God looks like in the Bible. Moses is told, "No one shall see me and live" (Exod 33: 20). But since 1512, Western man often visualizes God the way Michelangelo depicted him, as an older man with a long white beard, wearing flowing robes. In Byzantine art, God is frequently pictured sitting on a throne or on the orb of the world. In Michelangelo's vision, God is flying through the firmament, swirling, working with great energy to create the world. Creation is not a passive act, but one of unparalleled intensity. In Michelangelo's image, God soars through the sky.

Some art historians assume that Pope Julius II (Giuliano della Rovere), who commissioned the painting of the ceiling, was the model for the face of God.

Renaissance artists frequently included their patrons in their paintings. It was a way of acknowledging who funded the work. Michelangelo acknowledged his patron and the della Rovere family in other ways. But even a man with an ego the size of Pope Julius II's would not have encouraged Michelangelo to paint him as the image of God.

If one looks carefully at the images of God on the ceiling of the Sistine Chapel, it is easy to see that no two are the same. The various depictions have different facial features, different hair and beard styles, and different hair colors. They are representations of that which cannot be represented. Even an artist as great as Michelangelo would never presume through his work that he knew the face of God.

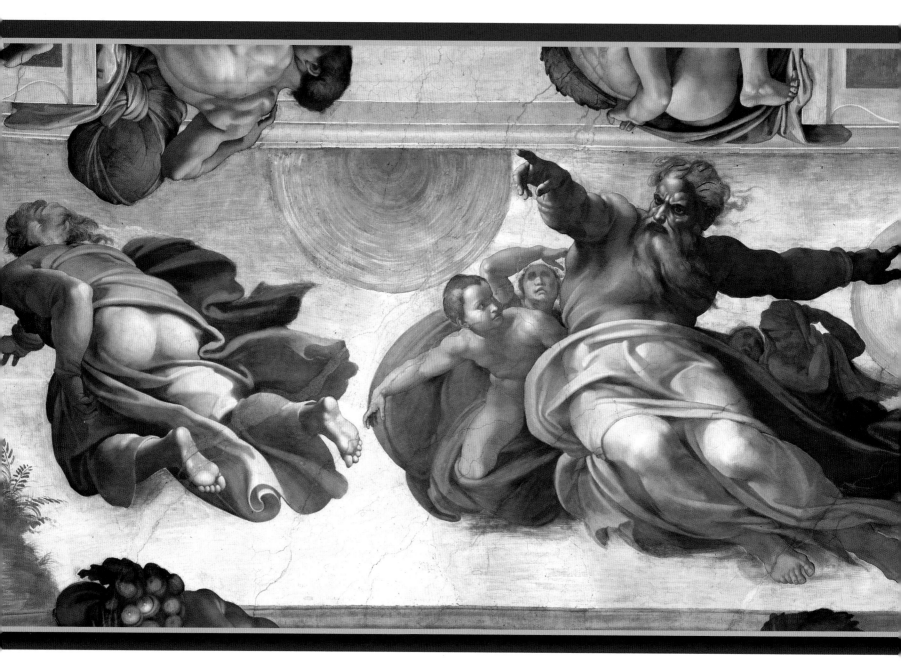

CREATION OF PLANTS AND THE SUN AND MOON

Then God said, "Let the earth put forth vegetation: plants yielding seed, and fruit trees of every kind on earth that bear fruit with the seed in it."... And God said, "Let there be lights in the dome of the sky to separate the day from the night; and let them be for signs and for seasons and for days and years, and let them be lights in the dome of the sky to give light upon the earth." And it was so.

—Genesis 1:11, 14–16

The sun and the moon were worshiped in pagan religions, which is not surprising given how essential they are for survival. The sun warms the earth and makes plants grow. Without plants, there is no food. The moon lights the night so that we are never in total darkness. The sun and the moon change in ways that early men could not have understood and may have found frightening.

But the God of the Bible is above all things. He creates the sun and moon with the same kind of energy and intensity that he used to separate the land from the sea. He soars through the air commanding the orbs to come into being. Then he turns and with a simple hand gesture creates plants on earth.

Most visitors are surprised to see the backside of God. Michelangelo was not just inserting humor into his work or "mooning" an impatient pope. This image is rooted in scripture. In Exodus 33:21–23, the Lord says to Moses, "See, there is a place by me where you shall stand on the rock; and while my glory passes by I will put you in a cleft of the rock, and I will cover you with my hand until I have passed by; then I will take away my hand, and you shall see my back; but my face shall not be seen."

The face of God in this painting is very similar to the face of Moses on the statue Michelangelo sculpted for the tomb of Pope Julius II. Showing two views of God in the same painting may have been Michelangelo's way of showing his skill as a sculptor and of returning to his favorite project.

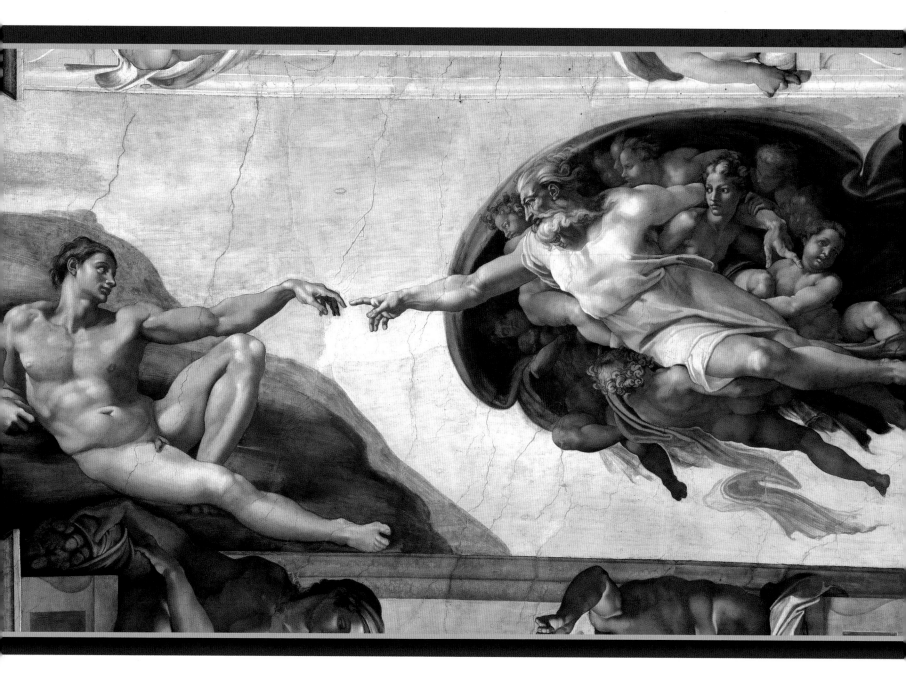

THE CREATION OF ADAM

Then the Lord God formed man from the dust of the ground, and breathed into his nostrils the breath of life; and the man became a living being . . . The Lord God took the man and put him in the garden of Eden to till it and keep it. And the Lord God commanded the man, "You may freely eat of every tree of the garden; but of the tree of the knowledge of good and evil you shall not eat, for in the day that you eat of it you shall die."

—**Genesis 2:7, 15–17**

The Creation of Adam is undoubtedly the most famous image on the entire ceiling. The detail of God's hand reaching out to touch Adam is instantly recognized by millions of people. That simple gesture has been repeated over and over in all kinds of media for all kinds of purposes. So it is sad to learn that the fingers on Adams left hand were among the first parts of the ceiling to deteriorate. They have been completely restored so that Michelangelo's brush strokes of that famous detail no longer exist.

The difference between God and Adam is striking. God continues his energetic work of creation while Adam lies there without the spirit necessary to reach toward God. Adam can only rest his forearm on his knee awaiting God's touch.

The Bible says God "blew into his nostrils the breath of life, and so man became a living being" (Gen 2:15–17).

The image of God imparting life through his touch is the product of Michelangelo's imagination and had not been seen before. The cloak that surrounds God and his assistants has been described as a cross section of the human brain. We know that Michelangelo did anatomical studies in preparation for his work, so he would have been familiar with its shape. It may represent that God is the all knowing, infinite mind from which all creation flows.

Who are those figures inside God's cloak? Some have suggested that the young woman under God's arm represents Eve watching the creation of Adam. The child whose shoulder is touched by God is said to represent his son, Jesus Christ. The skin tones of the figures range from pale to tawny, representing all races. For pagans, most gods were local. They had limited power and were worshiped by very few people. The god Michelangelo painted was a god for all people.

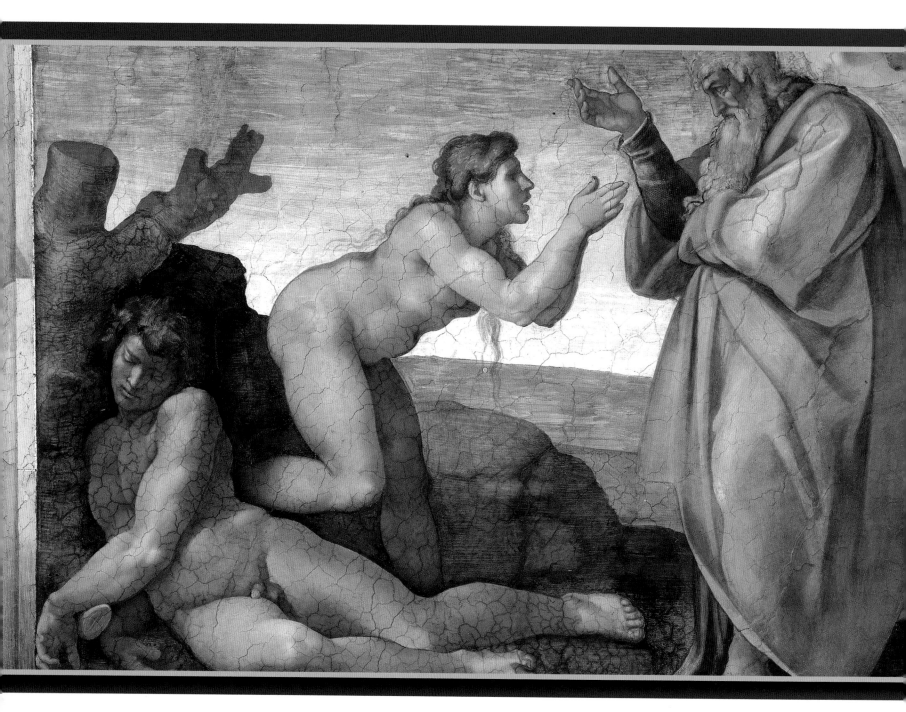

THE CREATION OF EVE

So the Lord God caused a deep sleep to fall upon the man, and he slept; then he took one of his ribs and closed up its place with flesh. And the rib that the Lord God had taken from the man he made into a woman and brought her to the man. Then the man said, "This at last is bone of my bones and flesh of my flesh; this one shall be called Woman, for out of Man this one was taken."

— Genesis 2:21–23

Unlike the first four stories from the Book of Genesis, God in *The Creation of Eve* is standing firmly on the earth. He raises his hand and seems to call forth Eve from Adam rather than to make her from Adam's rib. Eve comes forth as a strong person. She is muscular and looks God directly in the eyes. She was not created as a passive, dependent partner to Adam but as a being of equal stature. The early Church fathers saw Eve as representing the Catholic Church. The Church was formed from the blood and water that flowed from Christ's side as he hung on the cross. The Holy Mother, the Church, came from Christ's side just as Eve, the mother of humanity, came from Adam's side.

In this painting we see a dead tree for the first time, a figure that will be repeated in subsequent works. A dead tree represents the cross. The Romans crucified an alarming number of people. They did not have time to make enough planks for the executions, and sometimes they used trees stripped of their branches. The New Testament uses the word tree five times in refering to Christ's crucifixion on a cross. That is echoed in the line from the Negro spiritual, "Were you there when they nailed him to the tree?" The dead tree reminds us of our redemption through Christ's sacrifice on the cross.

Adam and Eve in *The Creation of Eve* are very youthful, almost adolescent. There is a freshness, an innocence about them. The creation was a period of great hope and promise for mankind. But like many adolescents, they moved toward greater independence and rebelled against authority.

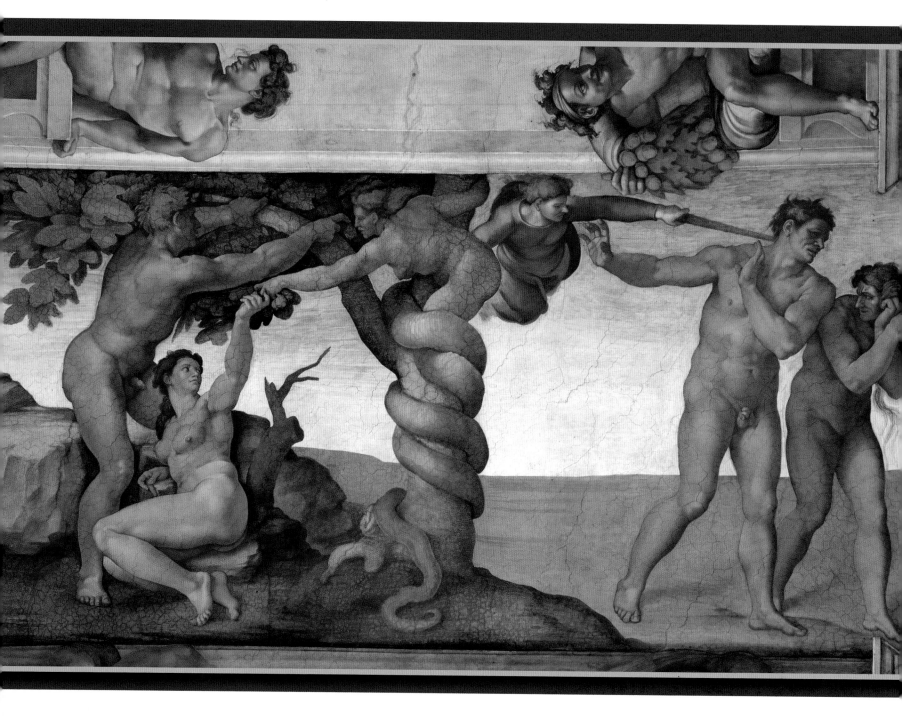

THE TEMPTATION AND FALL OF ADAM AND EVE

So when the woman saw that the tree was good for food, and that it was a delight to the eyes, and that the tree was to be desired to make one wise, she took of its fruit and ate; and she also gave some to her husband, who was with her, and he ate. Then the eyes of both were opened, and they knew that they were naked; and they sewed fig leaves together and made loincloths for themselves.

—**Genesis 3:6–7**

Michelangelo's *The Temptation and Fall of Adam and Eve* is startling. He uses the old style of telling a story in a single panel, but his vision is groundbreaking. Although he painted many nude figures throughout the Sistine Chapel, this is the only image that approaches the erotic.

Adam witnesses the temptation and takes an active part in it. Instead of being a victim of Eve's wiles, he is complicit in surrendering to the wiles of the Devil, who is painted as a beautiful woman to represent the attractive deceptiveness of sin.

For centuries, the fall of mankind has been blamed on Eve and by implication on women. This has been used to justify the subordination of women. Michelangelo apparently discounted that view.

He liberates Eve from the role of scapegoat and does not depict Adam as victim of her actions.

The consequences of sin are vividly portrayed in this fresco. Adam and Eve are strong and youthful in the Garden of Eden but look old and haggard after the expulsion. Even the landscape is barren and hostile. Their disobedience not only breached their relationship with God, but damaged them directly.

As they are forced to leave the garden, Adam is looking ahead, and Eve is looking back. There is a sense that the road ahead is filled with difficulties.

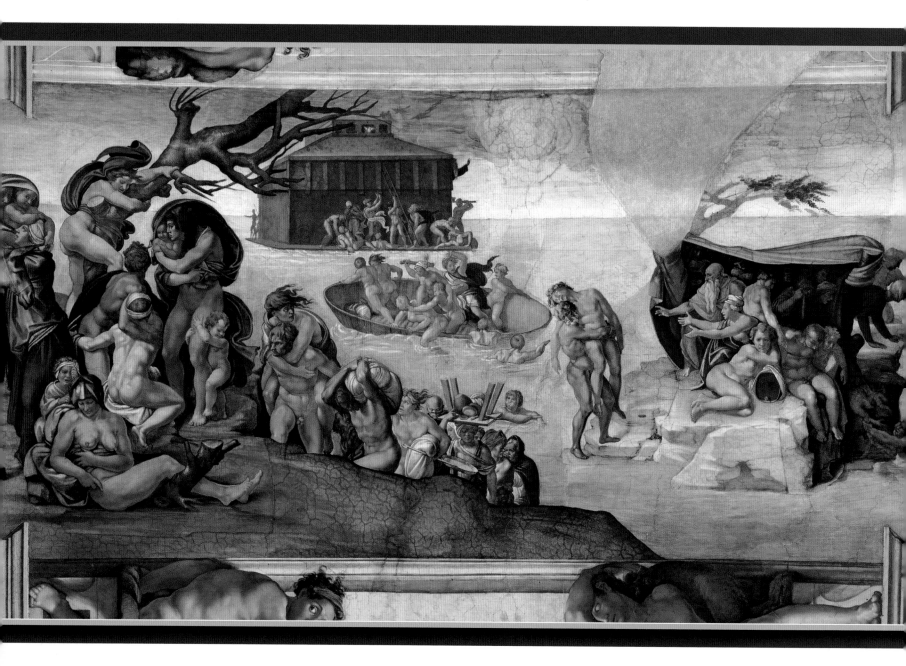

THE DELUGE

The Lord saw that the wickedness of humankind was great in the earth . . . And the Lord was sorry that he had made humankind on the earth, and it grieved him to his heart. So the Lord said, "I will blot out from the earth the human beings I have created—people together with animals and creeping things and birds of the air, for I am sorry that I have made them." But Noah found favor in the sight of the Lord . . . Noah was a righteous man, blameless in his generation; Noah walked with God.

—**Genesis 6:5–9**

Noah lived in a licentious time. God was disappointed with humanity and decided to wipe the slate clean and start over with Noah. In *The Temptation and Fall of Adam and Eve*, Michelangelo shows the wages of sin on individuals. In *The Deluge*, he shows the wages of sin on the community. Sin breaches man's relationship with God. It also harms the entire community.

Michelangelo vividly portrays reactions to adversity and calamity. Some, like the men in the boat, respond violently and try to save themselves at the expense of others. Some try to force their way aboard the ark and take Noah's place. Others cling to their possessions even though they weigh them down. Some seem passive and hopeless. The father carrying his lifeless son is

thought to represent God the Father with his Son who will be sacrificed in the future.

The dead tree is a symbol of the cross. It points to the ark, which looks more like a temple or church than a boat. The flood itself traditionally represents the waters of baptism, renewal, and the possibility of a new start.

Michelangelo painted more than sixty figures in this panel. In order to fit them all, the figures had to be small. At the unveiling of the first half of the ceiling, Michelangelo saw that smaller figures reduced the impact of the fresco. His later work employed fewer, larger figures. This reduced the time needed to complete the ceiling and satisfied Pope Julius II, who kept pressuring him to finish more quickly.

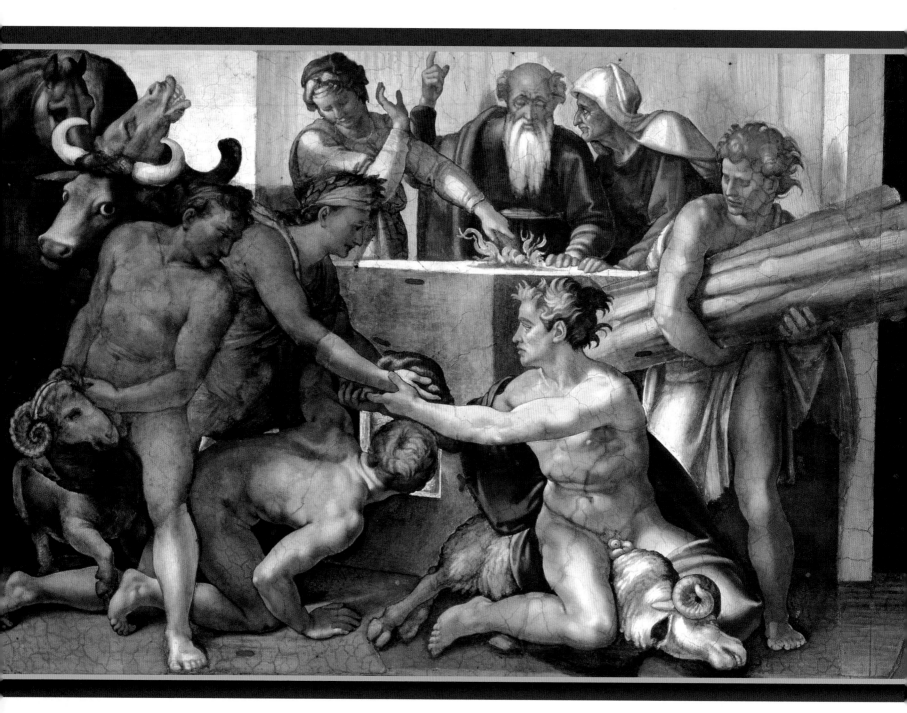

THE SACRIFICE OF NOAH

Then Noah built an altar to the Lord, and took of every clean animal and of every clean bird, and offered burnt offerings on the altar. And when the Lord smelled the pleasing odor, the Lord said in his heart, "I will never again curse the ground because of humankind, for the inclination of the human heart is evil from youth; nor will I ever again destroy every living creature as I have done."

—Genesis 8:20–21

*T*he Sacrifice of Noah depicts the sacrifice he made in thanksgiving for having been saved from the flood. Offering sacrifices of the finest animals and produce was an ancient Jewish tradition. It was a way of acknowledging God's help, especially in times of trouble. Smoke and pleasing smells from a sacrifice were thought of as prayers that rose directly to God. Incense is used in many religious ceremonies today to represent the direct ascent of petitions to God.

This scene suffered damage very early. The vault was not stable and the *intonaco*, the smooth layer of plaster on which the paint was applied, had begun to come away from the ceiling. Domenico Carnevali repainted the figures of the young man dragging the ram and the one taking the animal parts around 1568. It has been suggested that Carnevali may have made a tracing of the original paintings before he removed the *intonaco*. This allowed him to reproduce Michelangelo's figures as accurately as possible. During the restoration of 1980–1990, those figures looked lighter than the others in the scene. This might indicate that the effects of dirt and candle soot were already having an effect on the colors of the ceiling less than sixty years after Michelangelo began the work.

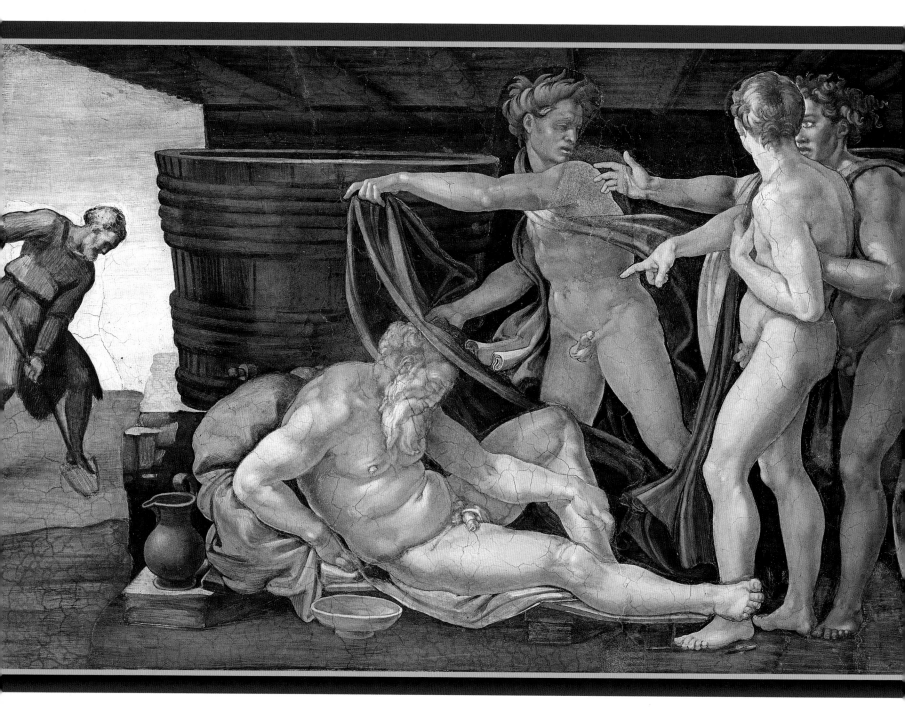

THE DRUNKENESS OF NOAH

[Noah] drank some of the wine and became drunk, and he lay uncovered in his tent. And Ham, the father of Canaan, saw the nakedness of his father, and told his two brothers outside. Then Shem and Japheth took a garment, laid it on both their shoulders, and walked backwards and covered the nakedness of their father; their faces were turned away, and they did not see their father's nakedness. When Noah awoke from his wine and knew what his youngest son had done to him, he said, "Cursed be Canaan; lowest of slaves shall he be to his brothers."

—Genesis 9:21–25

God saved Noah and his family from the Great Flood. They were given the chance for a fresh start, but their human failings remained.

There have been various interpretations of the meaning of this story that ended with Noah cursing his son Canaan. But no one has come up with a definitive explanation of the events and the biblical account does not give one.

Michelangelo captures the stress of the brothers in the presence of their naked, drunken father. Perhaps at some level they realized they were violating the dignity of their father who appears to be sleeping peacefully and in doing so were not paying him the honor which was due.

Noah was chagrined by the fact Canaan had walked in on him and then brought his other sons to the tent.

Michelangelo created more than three hundred figures in the Sistine Chapel. Noah and Adam are the only ones he painted in the same positions. Both are leaning against their right arms. Their left legs are bent and their left arms are resting against them. Their legs extend in exactly the same manner. This represents the similarity of Adam and Noah in the story of creation and salvation. Their attitudes, however, are very different. They are both passive, but Adam looks toward God with hopeful expectation. Adam is not fully animated, but is about to be inspirited by God. Noah for the time being is oblivious to what is taking place.

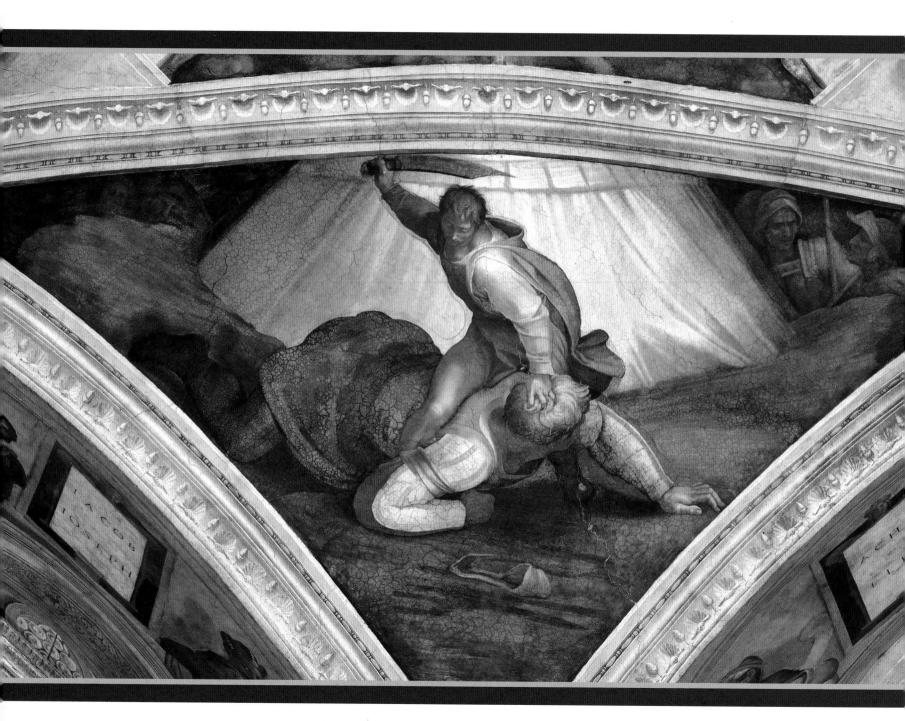

DAVID AND GOLIATH

And the Philistine cursed David by his gods. The Philistine said to David, "Come to me, and I will give your flesh to the birds of the air and to the wild animals of the field." But David said to the Philistine, "You come to me with sword and spear and javelin; but I come to you in the name of the Lord of hosts, the God of the armies of Israel, whom you have defied. This very day the Lord will deliver you into my hand, and I will strike you down and cut off your head."

—1 Samuel 17:43–46

The spandrels, the large curved triangular areas at the corners of the ceiling, are filled with stories from the Old Testament. Painting in a curved space presented quite a technical challenge for Michelangelo. However, he was such a master of the use of perspective that the paintings appear flat even though they were done on a concave surface.

The stories in the spandrels told of God's mercy toward the Jewish people and their salvation from the oppression of their enemies. They were thought to prefigure the roles Christ and the Church would play for humanity. Familiar stories were painted near the entrance to the Sistine Chapel. The stories related to the crucifixion were painted directly over the altar where the crucifix is placed during Mass.

The story of David and Goliath is well-known. It is the tale of a young shepherd boy who slew the Philistine champion with a stone from his sling. David, who was destined to become King of Israel and an ancestor of Jesus, succeeded in doing what seemed impossible. David's prediction to Goliath, "This very day the Lord will deliver you into my hand, and I will strike you down and cut off your head"(1 Sam 17:46) was borne out.

David was the patron of Florence and a popular figure in Renaissance Art. Michelangelo's colossal statue of David was so esteemed that it was placed in front of the Palazzo Vecchio, the seat of Florentine government, and became a symbol of the greatness of Florence. In 1873, a gallery in the Academia Galleria was build especially to house it.

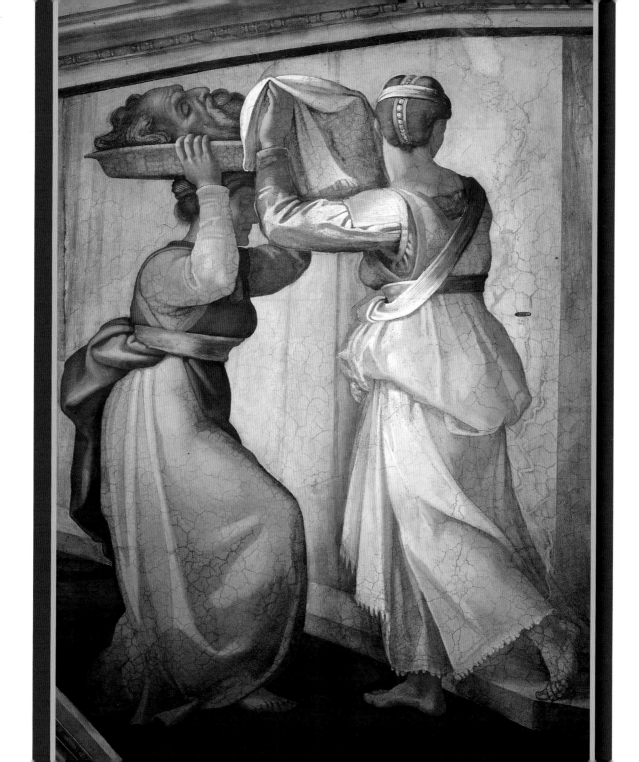

JUDITH AND HOLOFERNES

But Judith was left alone in the tent, with Holofernes stretched out on his bed, for he was dead drunk . . . She came close to his bed, took hold of the hair of his head, and said, "Give me strength today, O Lord God of Israel!" Then she struck his neck twice with all her might, and cut off his head.

— Judith 13:2, 7–8

Judith was a wealthy, beautiful, and courageous widow. When her city, and indeed all Israel, was threatened with destruction by the Assyrians under their chief general Holofernes, Judith emerged as a great heroine.

The Israelites had sworn an oath to capitulate to the enemy army if God did not rescue them within five days. Upon hearing of this, Judith berated the leaders for not trusting God and for putting him to a test. But the leaders could not go back on their oath.

Trusting in God and relying on her beauty, Judith went over to the enemy camp without disclosing her plan to the Israelite leaders. On her fourth day in the camp Holofernes invited her to a banquet. He fell asleep after drinking too much wine, and his servants left Judith alone with him.

Judith took his sword, and with two strokes cut off the general's head and brought it back to her city. The Assyrians panicked and were slain by the Israelites and the nation was saved.

Critics have often noted that Michelangelo was not at his best when painting the female form. Indeed, he used male models when rendering females. It has been said that he felt compelled to treat women as though they were another and less graceful sort of males.

Michelangelo's women in the Sistine Chapel are strong and imposing figures. Because he used male models for the preparatory drawings, their backs and chests are broad, and their arms and legs seem much too muscular.

Renaissance artists frequently inserted pictures of themselves in their compositions. It is thought that the head of Holofernes is one of several self-portraits Michelangelo included in the Sistine Chapel.

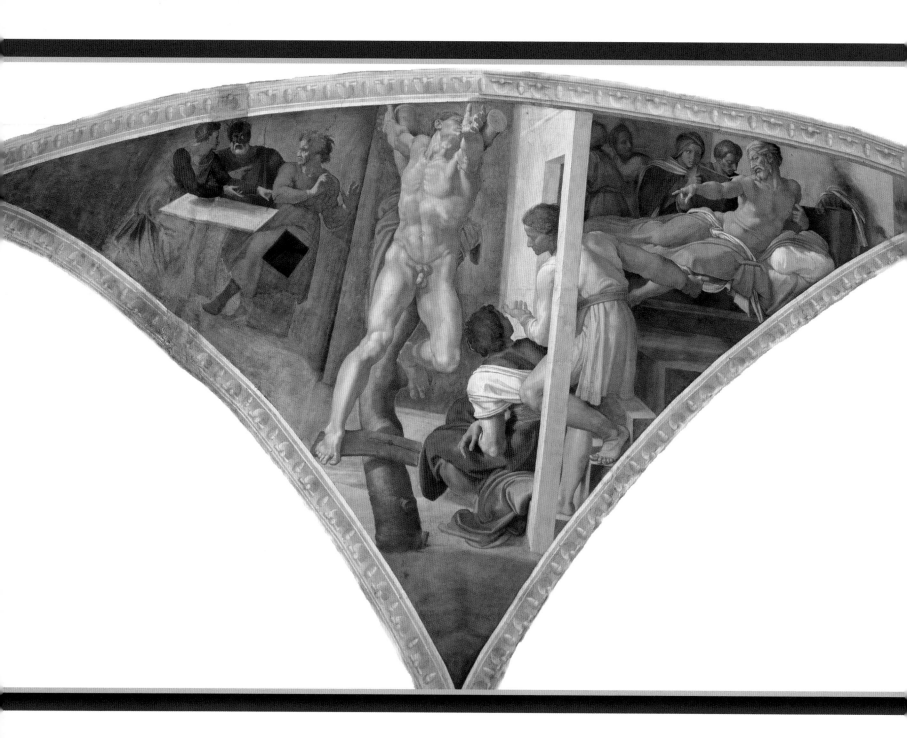

THE PUNISHMENT OF HAMAN

[Queen Esther petitioned the king for her own life and the lives of her people.] "For we have been sold, I and my people, to be destroyed, to be killed, and to be annihilated . . ." Then King Ahasuerus said to Queen Esther, "Who is he, and where is he, who has presumed to do this?" Esther said, "A foe and enemy, this wicked Haman!" . . . So they hanged Haman on the gallows that he had prepared for Mordecai.

—Esther 7:4–6, 10

The Punishment of Haman is painted on one of the two spandrels near the altar wall. The parallel between the crucifix on the altar and Haman hanging on a gibbet is unmistakable. Gibbets were gallows-like structures on which criminals were hanged after they were executed. They were used to hold the criminals up to public scorn. Christ, like Haman, was scorned and reviled. Once again, Michelangelo uses the image of a dead tree as the cross. And once again a woman brings salvation to her people. In this case, Queen Esther risked her life by coming before the king without being invited so that she could plead for her people.

Haman held a high position in the court of King Ahasuerus and expected everyone to kneel and bow when he appeared. Mordecai, the cousin and guardian of Queen Esther, refused. That so angered Haman that he decided to eliminate Mordecai by killing all the Jewish people in the kingdom. Esther was much loved by the king and won the safety of her people. This event is still commemorated by Jews every year as the Festival of Purim.

The Punishment of Haman was painted near the end of Michelangelo's work in the Sistine Chapel. It shows how he had mastered both the techniques of fresco and single point perspective. The painting was executed on a concave surface and yet the figure seems to project out towards the viewer. We can almost grasp Haman's hand. The greatest artists of that time, and for five hundred years, have marveled at Michelangelo's technique.

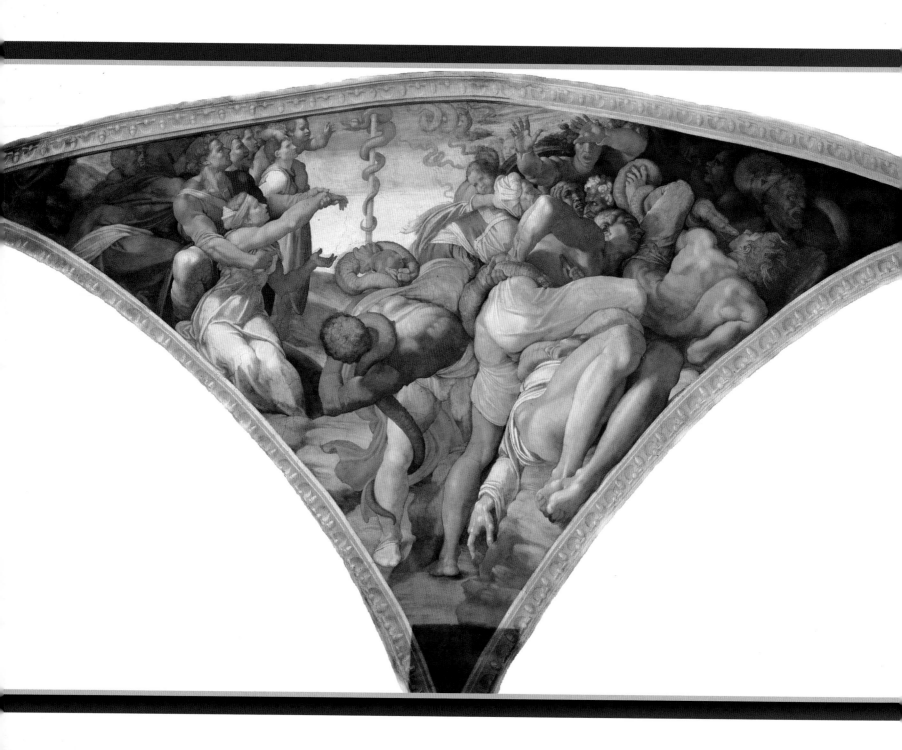

THE BRONZE SERPENT

The people spoke against God and against Moses, "Why have you brought us up out of Egypt to die in the wilderness? For there is no food and no water, and we detest this miserable food." Then the Lord sent poisonous serpents among the people, and they bit the people, so that many Israelites died . . . So Moses prayed for the people. And the Lord said to Moses, "Make a poisonous serpent, and set it on a pole; and everyone who is bitten shall look at it and live."

—Numbers 21:5–8

The Bronze Serpent was painted above the altar and is a foreshadowing of redemption through the cross. The Israelites, who were punished for complaints against God and Moses, were told that whoever looked to the bronze serpent would be saved, much as Christians are told whoever looks to the cross will not die, but have everlasting life. This same message is found in many stories in both the Old and New Testaments. God, as the creator of all things, gave man a few rules to follow. Man was told that if he followed those commandments, he would be saved, but the consequences of disobedience would be grave.

The serpent on the pole separates the survivors from those who perish. The survivors are to its right and those who perish to its left. The differences between the two groups are dramatic. The survivors to the right of the bronze serpent are standing erect and self-confident. They are filled with hope and reach toward the bronze serpent in expectation of salvation. A man in the foreground extends the hand of his female companion and helps her to be saved. The people to the left of the bronze serpent failed to heed the words of Moses and are tormented. Their expressions are of indescribable suffering and their bodies are twisted in pain. This is very similar to *The Last Judgment*, which Michelangelo would paint on the altar wall many years later. In that work, Christ separates the sinners from the saved. The saved are to his right and the sinners to his left. Because the imagery is so similar, it is sometimes difficult for contemporary visitors to remember that the altar wall was painted twenty-nine years later.

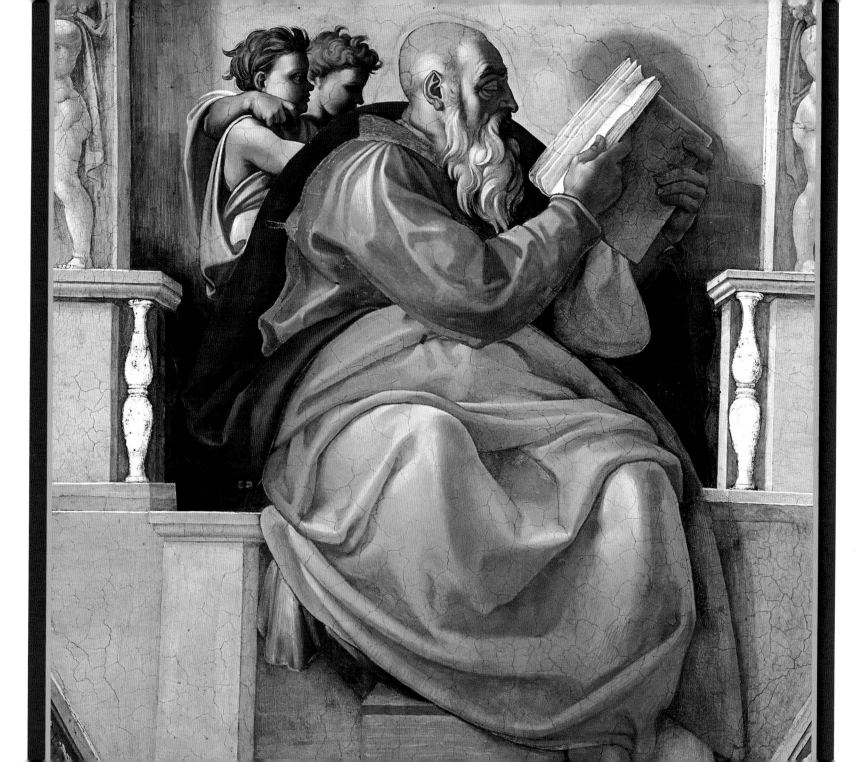

THE PROPHET ZECHARIAH

And I will pour out a spirit of compassion and supplication on the house of David and the inhabitants of Jerusalem, so that, when they look on the one whom they have pierced, they shall mourn for him, as one mourns for an only child, and weep bitterly over him, as one weeps over a first born.

—Zechariah 12:10

The Prophet Zechariah was painted over the entrance wall of the Sistine Chapel. He presides over this structure in the same way he presided over the rebuilding of the temple in Jerusalem. The Sistine Chapel was built to the same dimensions as the temple in Jerusalem.

Zechariah was a Messianic prophet. His writings foretold Palm Sunday (Passion Sunday): "Lo, your king comes to you; triumphant and victorious is he, humble and riding on a donkey" (Zech 9:9); and of the Passion of Christ: "When they look upon the one whom they have pierced" (Zech 12:10). He encouraged the return of exiles to Jerusalem, a return to faith in God. In Zechariah 8:22 he wrote: "Many peoples and strong nations shall come to seek the Lord of hosts in Jerusalem, and to entreat favor of the Lord."

Millions of visitors from all nations of the world and all stations of life have come to the Sistine Chapel in the past five hundred years. It is likely that the experience of viewing Michelangelo's ceiling has led some to return to their faith as Zechariah preached.

The figure of Zechariah is a portrait of Pope Julius II who hired Michelangelo to paint the ceiling in the chapel. It was common practice for artists to include a portrait of their patron in their work. The prophet's robes are gold and blue which are the colors of the pope's family, the della Roveres. Zechariah sits directly above the della Rovere coat of arms, which contains oak leaves and acorns because *rovere* means scrub oak. There are oak leaves and clusters of acorns throughout the ceiling in recognition of the role the della Rovere family had in the reconstruction of the chapel.

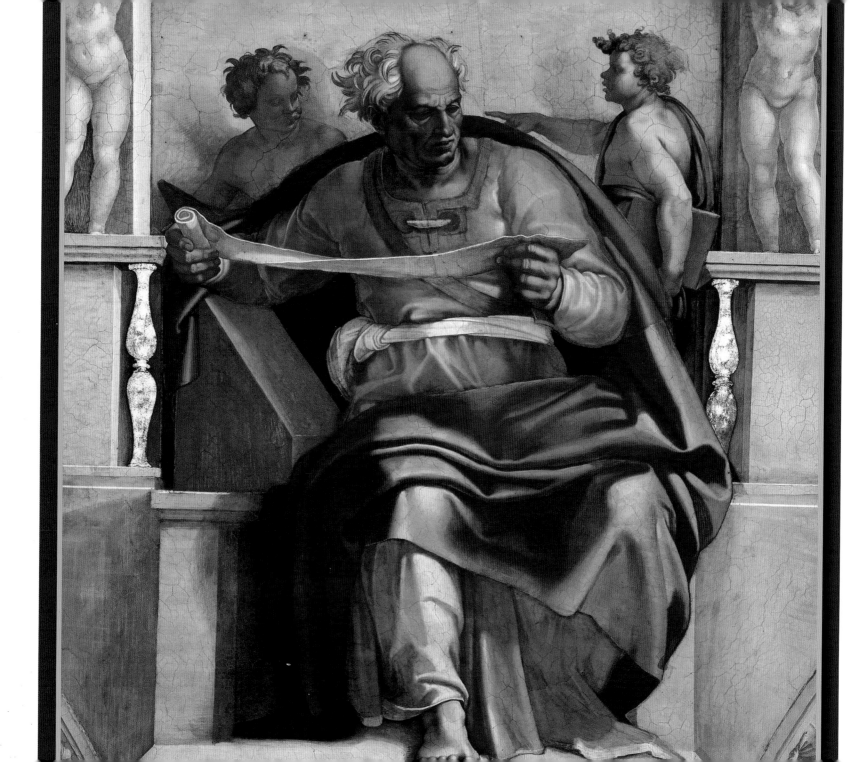

THE PROPHET JOEL

Then afterwards I will pour out my spirit on all flesh;
your sons and your daughters shall prophesy,
your old men shall dream dreams,
and your young men shall see visions.
Even on the male and female slaves,
in those days, I will pour out my spirit.

—Joel 2:28–29

Joel is a prophet of the apocalypse, the end of times. His writing is eschatological in tone and tells of the end of the world. He wrote, "The earth quakes before them, the heavens tremble. The sun and the moon are darkened, and the stars withdraw their shining" (Joel 2:10). Joel exhorts people to return to the Lord. "Yet even now says the Lord, return to me with all your heart, with fasting, with weeping, and with mourning" (Joel 2:12). But a god who is capable of destroying the world, is also a god of mercy. "Return to the Lord, your God, for he is gracious and merciful, slow to anger, and abounding in steadfast love" (Joel 2:13). Both Joel and Zechariah write of sinfulness and the need for man to return to faith and to abide by God's commandments.

Joel also prophesies the coming of the Holy Spirit, "I will pour out my spirit on all flesh" (Joel 2:28). Jesus promised that after his resurrection the Father would send the Holy Spirit in his name.

St. Peter, the rock on which Christ founded his church, preached about this passage from Joel in the Acts of the Apostles (3:17–21). He spoke about the coming of the Lord, the end of times, and the need to repent. St. Peter delivered this message on Pentecost. On that day the Holy Spirit descended and appeared as tongues of fire over the heads of each apostle. Filled with the Holy Spirit, the apostles began to preach to a crowd which had assembled. Some in the crowd thought they were drunk, but Peter quotes Joel to show that his prophecy was being fulfilled at that moment and that he and the others had been filled with the Holy Spirit.

Joel's inclusion in the Sistine Chapel continues the theological plan of the ceiling that moves the visitor from creation to sinfulness and, finally, at the altar, to salvation.

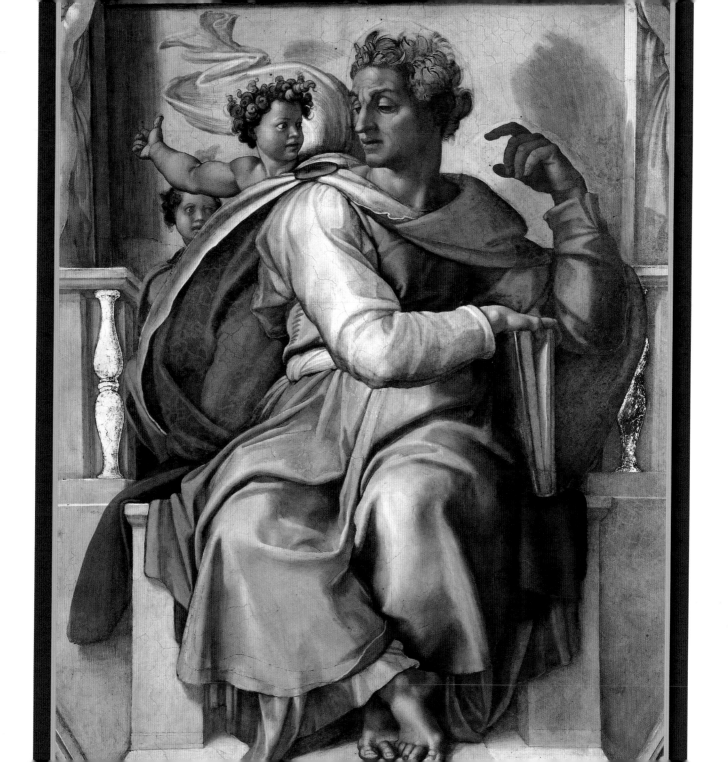

THE PROPHET ISAIAH

Surely he has borne our infirmities / and carried our diseases;

yet we accounted him stricken, / struck down by God, and afflicted.

But he was wounded for our transgressions, / crushed for our iniquities;

upon him was the punishment that made us whole, / and by his bruises we are healed.

All we like sheep have gone astray; / we have all turned to our own way,

and the Lord has laid on him / the iniquity of us all.

— Isaiah 53:4–6

Isaiah is considered by many Christians to be the greatest of the prophets and is sometimes called the prophet of the Passion. His writings were the most specific about the coming of the Messiah. He prophesied the virgin birth: "Therefore the Lord himself will give you this sign. Look, the young woman is with child and shall bear a son, and shall name him Immanuel" (Isa 7:14). He wrote of the birth of a Savior: "For a child has been born for us, a son given to us; authority rests upon his shoulders" (Isa 9:6). And he prophesied in great detail about the Passion of Christ. He even wrote of John the Baptist who "prepare[d] the way of the Lord" (Isa 40:3). Isaiah wrote these things approximately eight hundred years before the birth of Christ.

The genius of Michelangelo's work is that his people do not look static. He imbued his figures with the potential for movement. This is especially true for the Prophet Isaiah. His cape billows behind him as he turns suddenly to look at his companion. Isaiah was called to action in a very dramatic manner. An angel touched his lips with a burning coal to purify him of his sins. Then the Lord said, "Whom shall I send and who will go for us?" Isaiah replied "Here am I; send me!" (Isa 6:8). Like other prophets Isaiah was depicted as barefoot. This was particularly significant in his case since God ordered him to go barefoot for a period of three years.

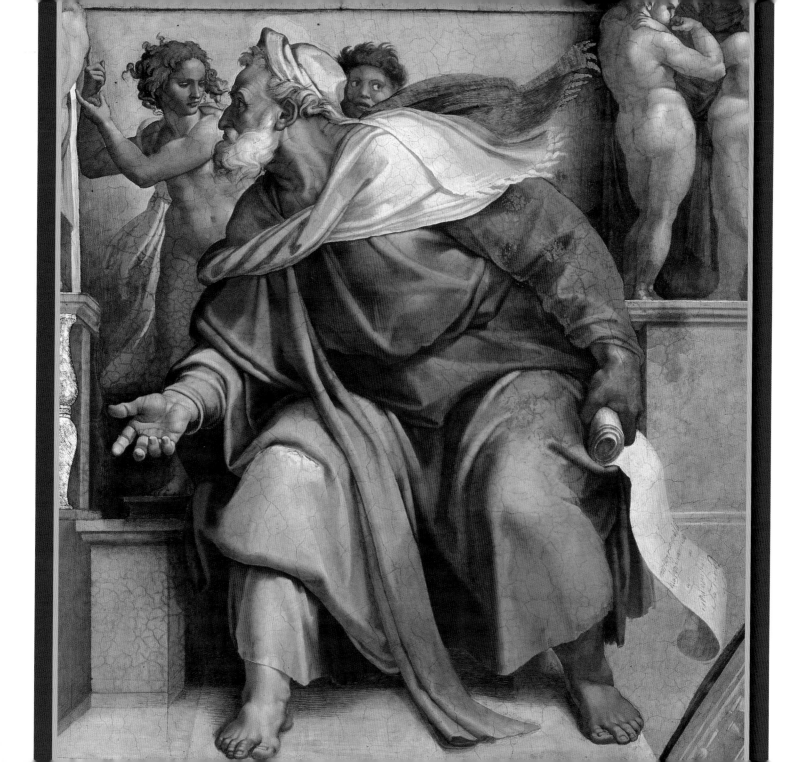

THE PROPHET EZEKIEL

I will sprinkle clean water upon you, and you shall be clean from all your unclean-nesses, and from all your idols I will cleanse you. A new heart I will give you, and a new spirit I will put within you; and I will remove from your body the heart of stone and give you a heart of flesh. I will put my spirit within you.

—Ezekiel 36:25–27

It is fitting that the prophet Ezekiel has found a home in the Sistine Chapel. The last eight chapters of the Book of Ezekiel detail the plans for rebuilding the temple in Jerusalem. He would be happy to find so great a painting of himself in a chapel built to the same dimensions as the temple he designed. He was a priest as well as a prophet and interested in liturgy, how the faithful should worship God. So there were many parallels between Ezekiel and Pope Julius II who was also a priest and also rebuilding a temple.

Ezekiel looks startled as he turns away from his work. Does he hear the voice of God? Like most prophets in the Old Testament, Ezekiel preached turning away from evil and the possibility of redemption for our sins. He helped to prepare for the New Testament doctrine of salvation through the redeeming grace of God.

Ezekiel is most remembered for his dramatic visions. The verse quoted above reminds us of Jesus' statement:

"No one can enter the kingdom of God without being born of water and Spirit." (John 3:5) and his injunction to the apostles, "Go therefore and make disciples of all nations, baptizing them in the name of the Father and of the Son and of the Holy Spirit" (Matt: 28:19).

Ezekiel also prophesied the resurrection from the dead. His words have come to symbolize not just the resurrection of a savior, but of all men at the end of times. "Thus says the Lord God: I am going to open your graves, and bring you up from your graves" (Ezek 37:12). Ezekiel wrote, "Thus says the Lord God to these bones: I will cause breath to enter you, and you shall live. I will lay sinews on you, and will cause flesh to come upon you, and cover you with skin, and put breath in you" (Ezek 37:5–6). Artists have used this passage as a guide when painting scenes of the Last Judgment for centuries.

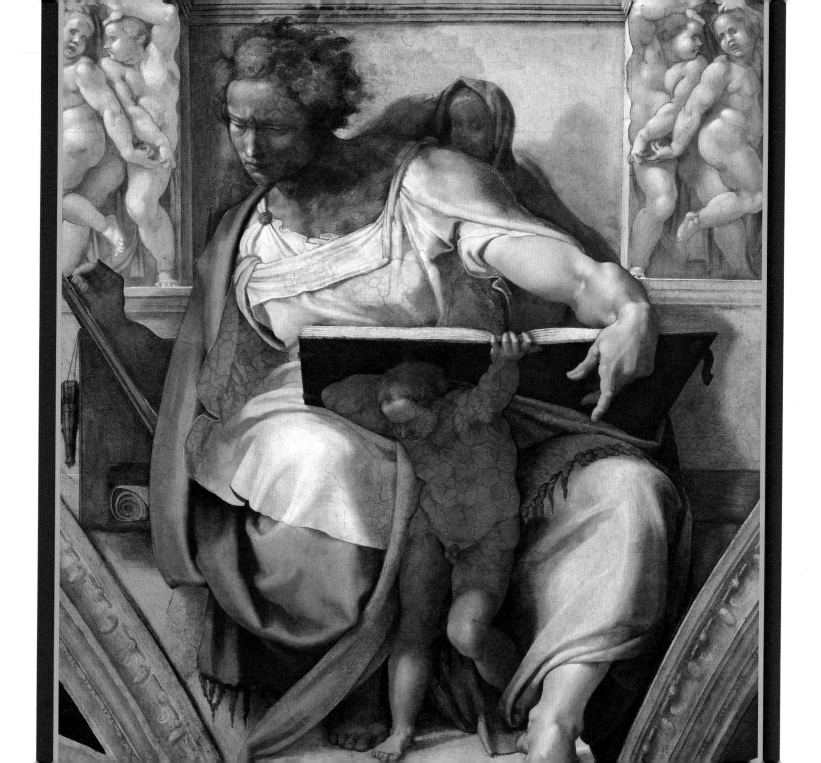

THE PROPHET DANIEL

As I watched in the night visions,
I saw one like a human being coming with the clouds of heaven.
And he came to the Ancient One and was presented before him.
To him was given dominion and glory and kingship,
that all peoples, nations, and languages should serve him.
His dominion is an everlasting dominion that shall not pass away,
and his kingship is one that shall never be destroyed.

—Daniel 7:13–14

Many are familiar with the story of Daniel in the lions' den. Daniel lived at the time of the Babelonian Captivity. He had considerable talents. Even though he was a Jew, he was trained for the service of King Nebuchadnezzar. He worked as an administrator until his skill at interpreting dreams and signs became known, then he became an advisor to the king. When he refused to forsake his religion, he was cast into the lions' den. God sent an angel to close the lions' mouths, and Daniel lived.

Daniel also wrote about Shadrach, Meshach, and Abednego. When they refused to worship a golden statue of King Nebuchadnezzar, they were thrown into a blazing furnace. The men who threw them into the furnace were killed by the heat, but Shadrach, Meshach, and Abednego were untouched by the flame. "Blessed be the God of Shadrach, Meschach, and Abednego, who has sent his angel and delivered his servants who trusted in him" (Dan 3:28). Those who attempted to harm the faithful died, but the faithful lived by the grace of God. This was an important message to first-century Christians who were experiencing persecution at the hands of the Roman emperors, and it continues to be an important message for the faithful today.

Daniel is depicted as he writes down the terrifying visions he received in dreams. "I, Daniel, found my spirit troubled within me, and the visions of my head terrified me" (Dan 7:15).

He refers to a weighty book, possibly the scriptures, and he needs the assistance of a muscular *putto* to help hold the text.

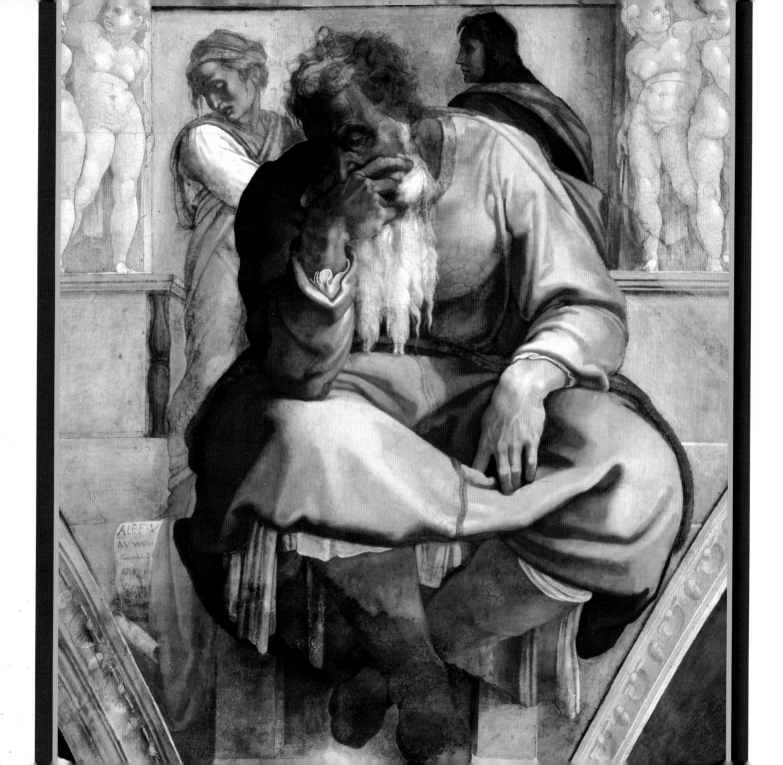

THE PROPHET JEREMIAH

The days are surely coming, says the Lord, when I will raise up for David a righteous Branch, and he shall reign as king and deal wisely, and shall execute justice and righteousness in the land. In his days Judah will be saved and Israel will live in safety. And this is the name by which he will be called: "The Lord is our righteousness."

—Jeremiah 23:5–6

The Prophet Jeremiah is old and weary, bent over with exhaustion. This portrait does not include the scrolls or books that usually accompany the prophets. He is too tired to continue his efforts.

The fresco is near the altar wall and was completed near the end of Michelangelo's work in the Sistine Chapel. By this time, Michelangelo was also weary. He complained that working on the ceiling hurt his back and neck and damaged his eyesight. It was said that for years after completing the ceiling he was forced to hold papers above his head in order to read them.

The Prophet Jeremiah is thought to be another self-portrait of the artist. Jeremiah is the only prophet with shoes. They resemble the leather leggings favored by Michelangelo and described by his biographer Condivi in *The Life of Michelangelo.*

Jeremiah is frustrated because, like most prophets, he has given a similar message to the people of Israel. He may have used different images, but the message was the same. Repent and be saved. Jeremiah was very concerned with the false gods that too many Jews had chosen to worship during their exile from Jerusalem. Unlike God the Father who had continued to show mercy to his people, false gods "will never save them in the time of their trouble" (Jer 11:12). But the people did not obey and reform their ways. They were still in need of another prophet, Jesus Christ.

The Prophet Jeremiah became a model for other artists. Like many, the well-known French sculpture August Rodin studied in Italy. It is said that this painting influenced his famous sculpture *The Thinker.*

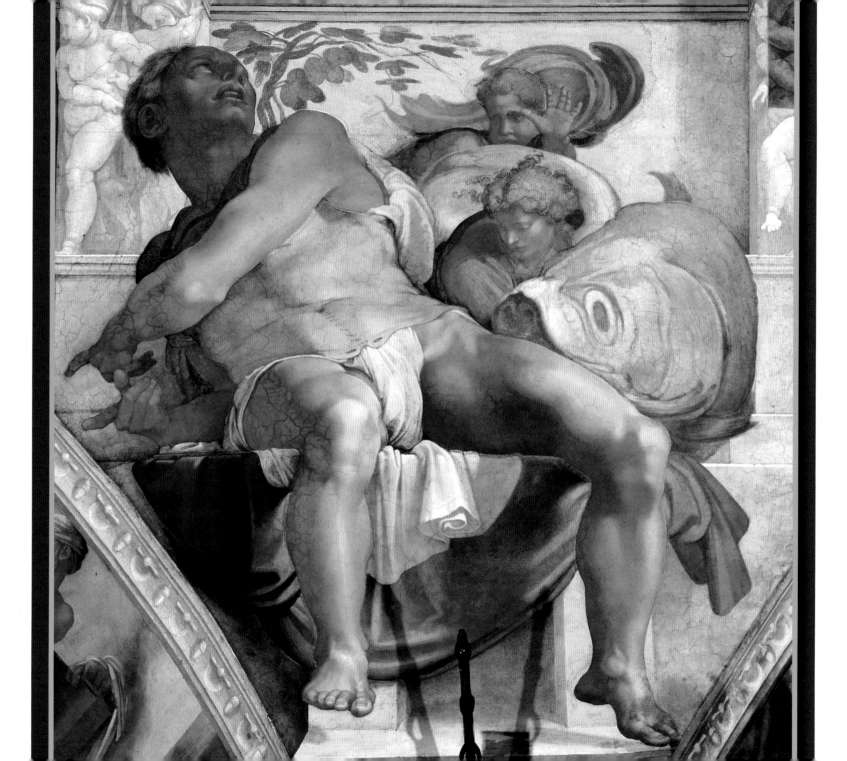

THE PROPHET JONAH

But the Lord provided a large fish to swallow up Jonah; and Jonah was in the belly of the fish for three days and three nights....Then Jonah prayed to the Lord his God from the belly of the fish, saying, "I called to the Lord out of my distress, and he answered me; out of the belly of Sheol I cried, and you heard my voice."

—Jonah 1:17; 2:1–2

The story of Jonah is quite familiar. In order to avoid carrying out God's command to tell the Ninevites of their need to repent, Jonah decided to take a sea voyage to Tarshish. In the storm that followed, Jonah was thrown overboard to save the ship, and he spent three days in the belly of a whale.

At last Jonah went to Nineveh, and the people repented, and Jonah became angry with God because he did not destroy the city.

The fresco is directly over the altar and prefigures the resurrection of Christ. When Christ was asked for a sign, he said he would only give the sign of Jonah, and that as Jonah spent three days and nights in the belly of a whale, he would spend three days and nights in the heart of the earth.

Michelangelo painted Jonah as a very striking and alarming figure, and the portrait is another triumph in the use of perspective by the artist. The ceiling is concave at that point, and yet we see Jonah leaning backward with his legs jutting out towards us. It looks as if it had been painted in three dimensions rather than in a curved section of the ceiling. The greatest artists of the day were astounded at Michelangelo's brilliant use of the technique.

Jonah leans back and stares directly at the fresco depicting God separating light from darkness. He is witnessing creation. And he is afraid. The fish next to him is obviously a symbol of the whale. The plant behind him recalls that after Nineveh repented, God let a plant grow up to give the prophet shade and spare him from the heat. But because of Jonah's anger God sent a worm to destroy the plant, leaving the prophet to say he would be better off dead.

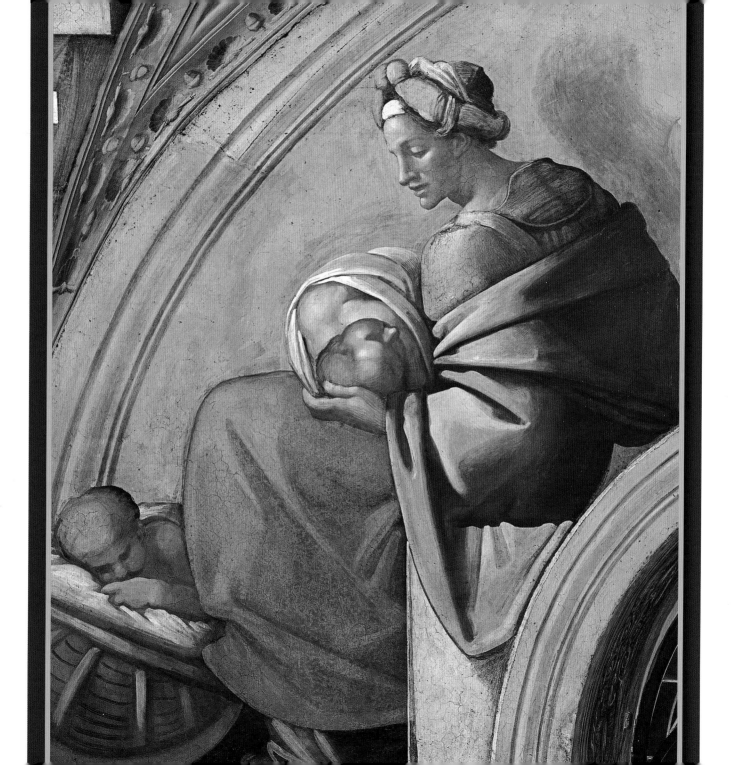

Genealogy of Jesus

Michelangelo painted the ancestors of Christ as chronicled by Matthew (Matt 1:1–7). They can be found in the lunettes that sit atop the arched windows in the Sistine Chapel. Some are beneath the prophet Zechariah on the entrance wall and beneath the stories from the Old Testament. They are called lunettes because they are shaped like crescent moons. Eight triangular-shaped sections called spandrels sit above the lunettes along the central spine of the ceiling. They flank the large scenes from the Book of Genesis. The spandrels also include family groups that represent the ancestors of Christ. However, they are of a general nature and are not directly tied to the ancestors in the adjacent lunettes. The lunettes and spandrels are small compared to the other areas of the ceiling and provided limited space for the artist to work. So Michelangelo painted all the figures seated or reclining so that they could be drawn larger and therefore could be seen more easily from the floor of the chapel.

The ancestors of Christ were painted very quickly, none in more than four days. No cartoons or tracings were used. Michelangelo painted directly on the wet plaster free style. Since they were painted on flat surfaces, he could paint while standing and could move back and forth on the scaffolding to get a better view of his work. That was not possible when he painted the central spine of the ceiling or the curved spandrels. In the center of each lunette is a plaque resting in its own frame that bears the names of Christ's relatives. The plaques are held by bronze figures with a female head at the top.

The figures in the lunettes do not correspond well to the names on the plaques. There is very little information in the Bible regarding many of the forty-two generations that preceded Christ. Some of his distant relatives

like King David and King Solomon are well known. But even the figures in the lunette bearing their names do not remind us of them. There is nothing to remind us that David was the shepherd boy who slew Goliath and became king or that Solomon was the great king who built the temple in Jerusalem. Michelangelo did not intend to paint realistic likenesses of the ancestors named in each lunette. The purpose of this collection of family portraits appears to be to demonstrate the relationship of Christ to the Jewish people and that he was from a noble line of kings. Christ, after all, was to become the King of Kings.

Although Michelangelo did not intend to represent Christ's extended family accurately, he did create a catalog of the life of the human family. Christ was both divine and human. The family of man was part of his heritage and nature. All the figures are in different positions and express different feelings. Some are afraid and apprehensive, some angry. Some express love and tenderness. Some of the figures are detached and isolated from the others even though in the same family group. It is interesting to note that the negative emotions portrayed are most often expressed by men. The men are also painted with much more somber colors than the women. All the stages of human development, from infancy to old age, are represented. Christ's ancestors resemble our own. The architectural details around the families serve to hold them together.

The genealogy of Jesus, according to Matthew, begins with Abraham. Two lunettes picturing Abraham and his descendents were painted on the altar wall. However, they were destroyed when Michelangelo returned to the Sistine Chapel in 1536. He had them removed when he began work on his final fresco, *The Last Judgment*. So our visit with Christ's ancestors will begin with Aminadab.

An account of the genealogy of Jesus the Messiah, the son of David, the son of Abraham.

Abraham was the father of Isaac, and Isaac the father of Jacob, and Jacob the father of Judah and his brothers, and Judah the father of Perez and Zerah by Tamar, and Perez the father of Hezron, and Hezron the father of Aram, and Aram the father of Aminadab, and Aminadab the father of Nahshon, and Nahshon the father of Salmon, and Salmon the father of Boaz by Rahab, and Boaz the father of Obed by Ruth, and Obed the father of Jesse, and Jesse the father of King David.

And David was the father of Solomon by the wife of Uriah, and Solomon the father of Rehoboam, and Rehoboam the father of Abijah, and Abijah the father of Asaph, and Asaph the father of Jehoshaphat, and Jehoshaphat the father of Joram, and Joram the father of Uzziah, and Uzziah the father of Jotham, and Jotham the father of Ahaz, and Ahaz the father of Hezekiah, and Hezekiah the father of Manasseh, and Manasseh the father of Amos, and Amos the father of Josiah, and Josiah the father of Jechoniah and his brothers, at the time of the deportation to Babylon.

And after the deportation to Babylon: Jechoniah was the father of Salathiel, and Salathiel the father of Zerubbabel, and Zerubbabel the father of Abiud, and Abiud the father of Eliakim, and Eliakim the father of Azor, and Azor the father of Zadok, and Zadok the father of Achim, and Achim the father of Eliud, and Eliud the father of Eleazar, and Eleazar the father of Matthan, and Matthan the father of Jacob, and Jacob the father of Joseph the husband of Mary, of whom Jesus was born, who is called the Messiah.

So all the generations from Abraham to David are fourteen generations; and from David to the deportation to Babylon, fourteen generations; and from the deportation to Babylon to the Messiah, fourteen generations.

—Matthew 1:1–17

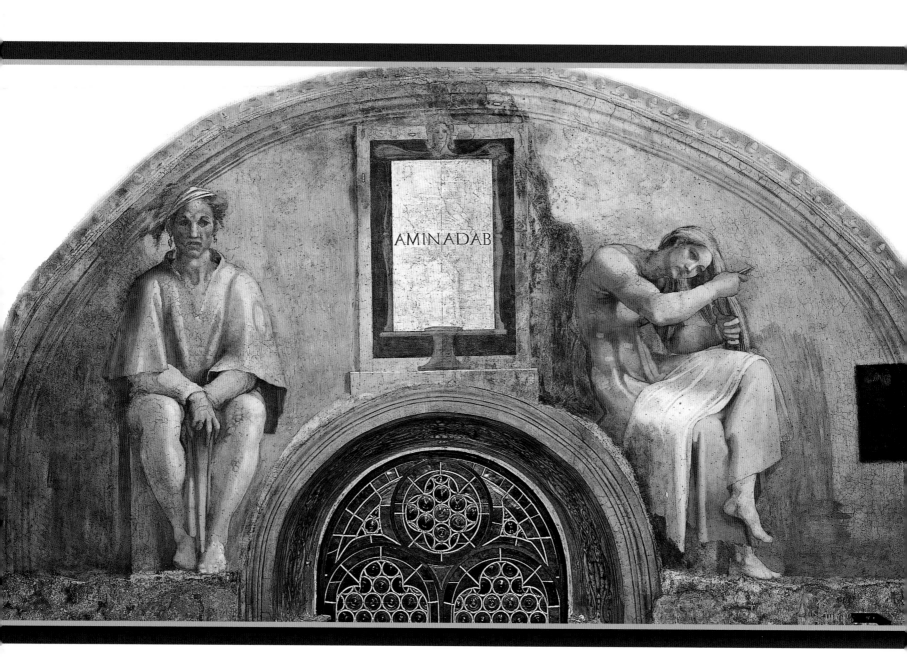

AMINADAB

I will take you as my people, and I will be your God. You shall know that I am the Lord your God, who has freed you from the burdens of the Egyptians. I will bring you into the land that I swore to give to Abraham, Isaac, and Jacob; I will give it to you for a possession. I am the Lord.

—Exodus 6:7–8

The New Testament contains two very different genealogies of Christ, one by Matthew and one by Luke. Matthew traces Christ's ancestors to the great patriarch, Abraham, and Luke to the first man, Adam. It is impossible to determine which is accurate. Both genealogies are literary devices designed to show Christ's humanity, relationship to the Jewish people, and connection to the Old Testament. Michelangelo used Matthew's genealogy as a guide for his work in the Sistine Chapel.

Aminadab was a Levite prince and descended from Abraham. He is remembered most for his children. He was the father of Nahshon. His daughter Elisheba married Aaron, the brother of Moses. As Aaron's father-in-law, he had a significant role in the Exodus. He was selected to assist Moses in moving the Twelve Tribes of Israel to the Promised Land. He was of the house or tribe of Judah.

The figures in this lunette are young, in the prime of life. The man on the left is tense. He looks worried about his future. After all, it would be his responsibility to support a family and carry on the family name. The woman on the right is one of the most comely in the entire ceiling. She is pictured taking care of her beautiful blond hair and making herself more attractive. She appears more confident than the man that she will make a good match and fulfill her social obligation to produce an heir for her husband's family. Women during the Renaissance were valued for their reproductive capacity. Given the high rate of infant mortality and the rate of death during childbirth, it was essential for women to have many children to ensure that the population remained stable.

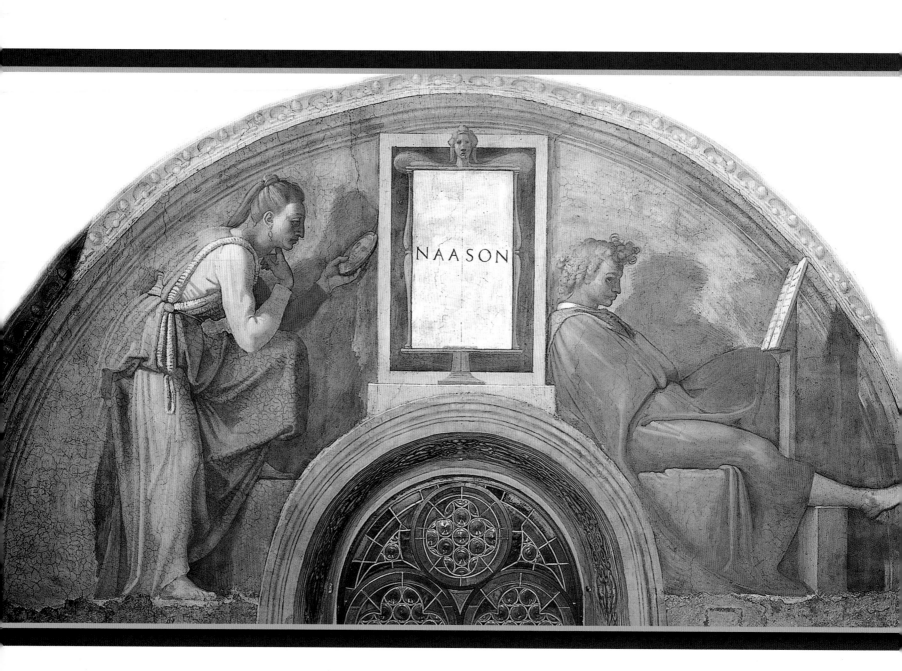

NAASON

Nahshon

The Lord bless you and keep you;
the Lord make his face to shine upon you, and be gracious to you;
the Lord lift up his countenance upon you, and give you peace.
— Numbers 6:24–26

Moses and his people had been wandering in the desert for more than two years when the Lord requested that he take a census of the people. Nahshon, son of Aminadab, of the tribe of Judah was selected to assist him.

Nahshon became the head of the people of Judah and supervised their encampment. The total enrollment of the camp of Judah, which meant all the men over the age of twenty, was 186,400. He was the political leader of his people but also offered sacrifices in the tabernacle of the Lord. His first offering consisted of silver, flour mixed with oil, gold, incense, one young bull, one ram, one male lamb for a burnt offering and one male goat for a sin offering, two oxen, five rams, five male goats, and five male lambs (Num 7:12–17). Nahshon died in the wilderness and never made it to the Promised Land.

The woman on the left might have been derived from a portrait of the muse Melpomene on a Roman sarcophagus. Michelangelo had the opportunity to study the bas relief and two small preparatory drawings based on the work have been found. She gazes at her face in a mirror and, like the woman in the previous lunette, appears very concerned with her appearance. Women in the Renaissance were also valued for their potential to form alliances between families. Such alliances helped in maintaining the peace since a duke would be less likely to attack a city where his daughter and grandchildren resided. An attractive woman would have a better chance of making a favorable alliance. This use of women was not limited to the Renaissance, but can be found throughout history.

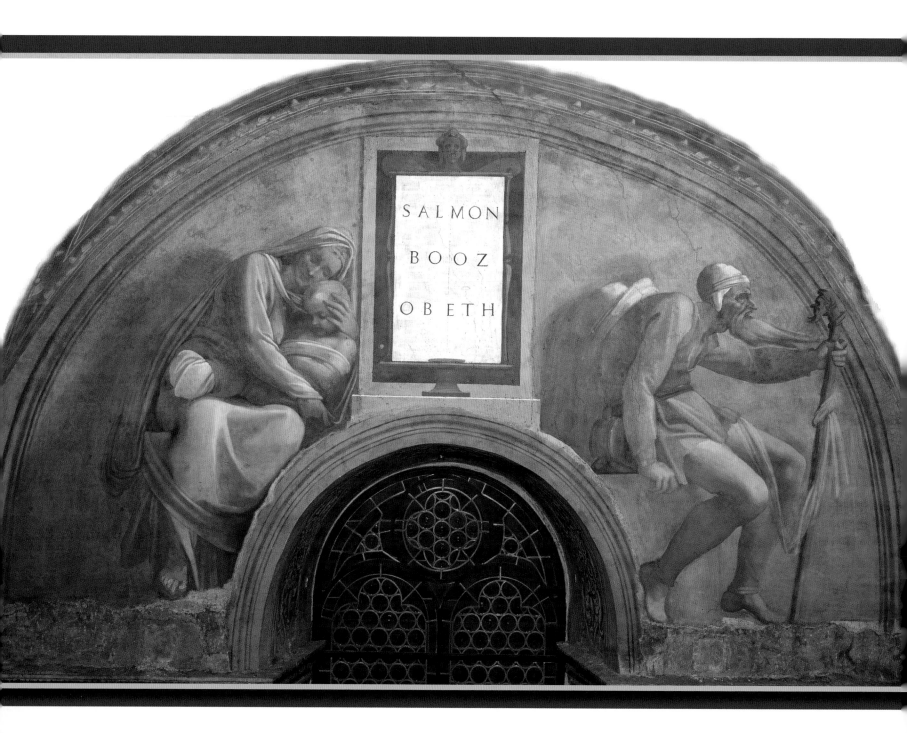

Salmon, Boaz, and Obed

So Boaz took Ruth and she became his wife. When they came together, the Lord made her conceive, and she bore a son. Then the women said to Naomi, "Blessed be the Lord, who has not left you this day without next-of-kin; and may his name be renowned in Israel!"

—Ruth 4:13–14

In the days of the Old Testament, to be without family was to be without economic or social support and to be unprotected. When Naomi's husband and sons died, she returned to the city of her birth, Bethlehem. Her daughter-in-law Ruth, a new widow herself, refused to leave Naomi and went with her to Bethlehem. With no means of support, Ruth began to glean the fields of Boaz, a rich kinsman of Naomi. Gleaning was very difficult work. It meant going behind the harvesters and picking up any grain that they missed. Boaz noticed how hard she worked and offered her extra grain, water, and protection from the men in the fields. It was the custom in those days for a man to be responsible for the widow and children of his relatives. Eventually Boaz married Ruth. They had a son, Obed, who became the father of Jesse, who became the father of David.

This is one of the few lunettes where the figures bear some resemblance to the ancestors listed in the plaque. Boaz was considerably older than Ruth, and the man in the right half of the lunette is clearly advanced in years. However, he looks more like a pilgrim with his backpack and walking stick than a wealthy man with property. The young woman on the left has just completed nursing her son, perhaps Obed, and holds him with great tenderness. Michelangelo left her breast exposed. He often spoke of the importance of his own wet nurse, the wife of a stone carver in the village of Settignano. Michelangelo would jest that the marble dust in his nurse's milk set him on the path to become a stone carver. Perhaps this figure is an homage to his wet nurse as well as to Ruth.

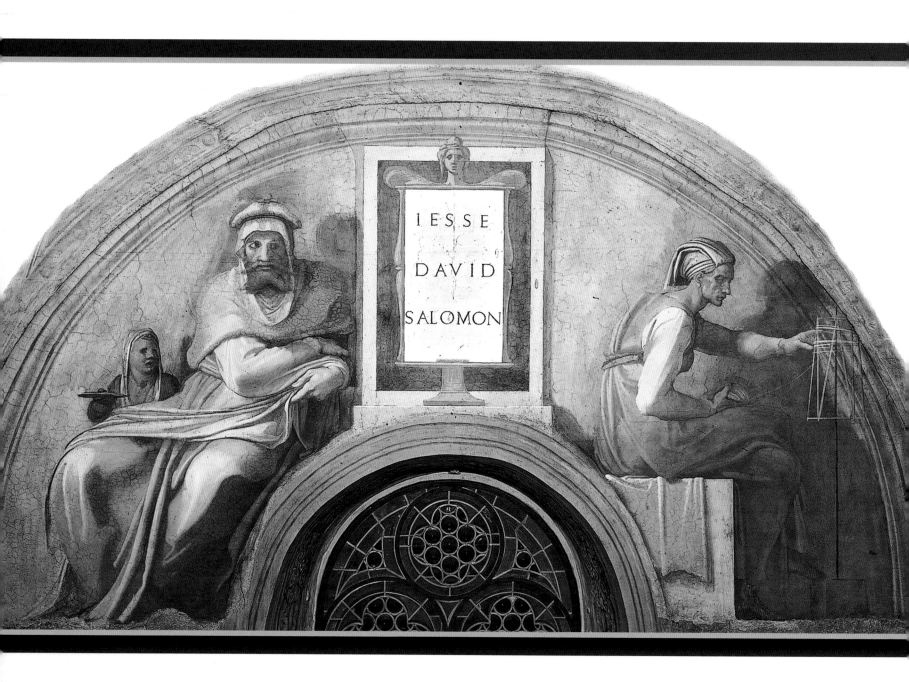

JESSE, DAVID, AND SOLOMON

[The tribes of Israel said:] "The Lord said to you: 'It is you who shall be shepherd of my people Israel, you who shall be ruler over Israel.' " So all the elders of Israel came to the king at Hebron; and King David made a covenant with them at Hebron before the Lord, and they anointed David king over Israel.

—2 Samuel 5:2–4

David is such an important figure in the story of the Jewish people and of Jesus that he is represented in the Sistine Chapel twice. We have already examined the painting in the large spandrel at the entrance to the chapel that depicts the young shepherd boy slaying the giant Goliath. David is painted once again as an ancestor of Christ. The prophet Jeremiah described Christ as the righteous branch of David.

The figure on the left is large and imposing as a king should be. He gazes away from the altar and looks worried, almost fearful. On his lap is a white cloth. Such cloths were common in Renaissance paintings of the Nativity and represented the shroud that would clothe Christ after his crucifixion. Does David know at some level what will happen to his most famous descendant?

The woman to the right of the plaque is thought to be Bathsheba. She was the wife of Uriah, the Hittitte, a warrior, when she began a relationship with David. David arranged to have Uriah slain in battle and then married Bathsheba.

This so displeased the Lord that David's first son died shortly after birth. His second son, conceived in marriage, was Solomon. Even the king of Israel would suffer the consequences of violating God's commandments. The figure behind David is thought to represent his son Solomon who succeeded him as king and built the great temple of the Lord in Jerusalem. That temple would be destroyed. Jesus preached in the second temple in Jerusalem, built after the Babylonian captivity.

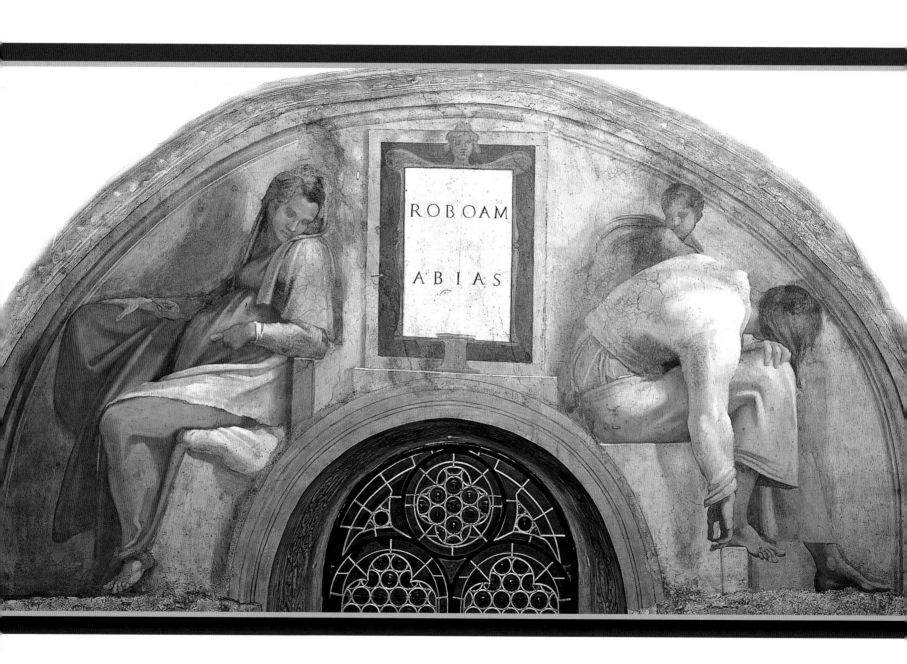

ROBOAM

ABIAS

Rehoboam and Abijah

[King Jeroboam son of Nebat] committed all the sins that his father did before him; his heart was not true to the Lord his God, like the heart of his father David. Nevertheless for David's sake the Lord his God gave him a lamp in Jerusalem, setting up his son after him, and establishing Jerusalem; because David did what was right in the sight of the Lord . . . except in the matter of Uriah the Hittite.

—1 Kings 15:3–5

We learned from the stories in the Book of Genesis and from the prophets that the people of Israel were not always true to their covenant with God. Adam and Eve sinned and were banished from the Garden of Eden. Noah succumbed to the effects of wine. Jonah did not want to be a prophet. The prophets repeatedly warned their people to repent their evil ways and to return to the Lord. The great kings of Israel were also sinful. Solomon was influenced by his many wives and concubines and turned his heart away from the Lord and worshiped false gods. King Jeroboam, who ruled over the northern tribes, went so far as to create golden calves for the people to worship. Rehoboam succeeded Solomon, but only ruled a part of his father's kingdom.

There was constant war between the tribes of Israel as well as with the Egyptians. Rehoboam was forced to give up King Solomon's treasures in his palace and temple to appease the Egyptians. He had twenty-eight sons and sixty daughters from his eighteen wives and sixty concubines. And from his sons he selected Abijah to succeed him as king.

The figures in this lunette do not seem to have much to do with the ancestors listed on the plaque between them. They are both sleeping, seemingly unconcerned with life around them. The woman leans back on her arm and strokes her pregnant belly. The young man is slumped forward, oblivious to the boy tugging at his shoulder. King Rehoboam and King Abijah might have been sleeping on the job. They were unmindful of their covenant with God and unaware of how much their people had strayed from God's commandments. Clearly, they were much in need of a redeemer.

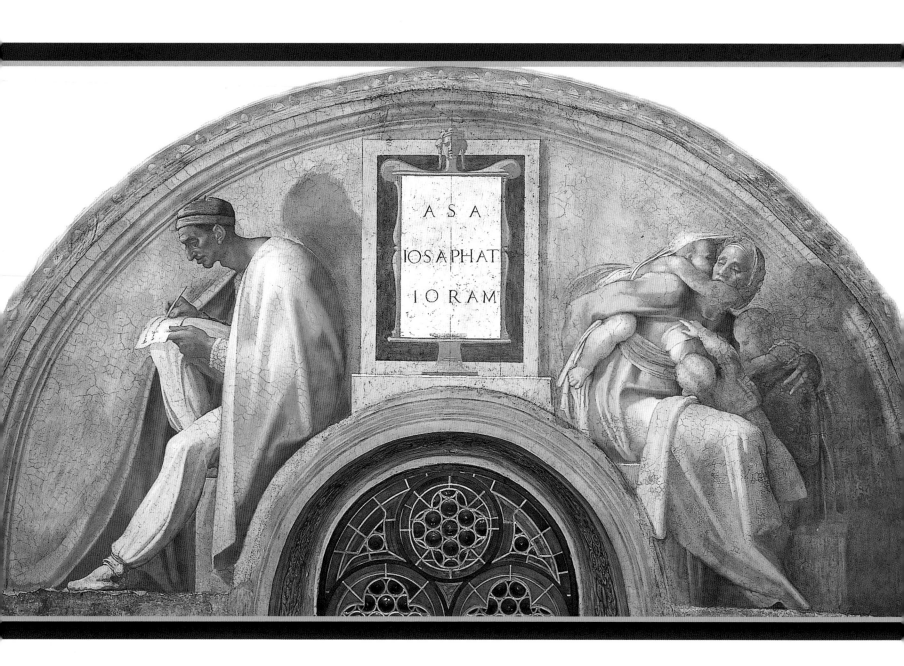

ASA, JEHOSHAPHAT, AND JEHORAM

[Asa succeeded Abijah as king.] Asa did what was good and right in the sight of the Lord his God . . . [His son Jehoshaphat succeeded him.] The Lord was with Jehoshaphat, because he walked in the earlier ways of his father . . . When Jehoram had ascended the throne of his father [Jehoshaphat] and was established, he put all his brothers to the sword, and also some of the officials of Israel . . . He did what was evil in the sight of the Lord.

—2 Chronicles 14:2; 17:3; 21:4–6

The kings that followed Solomon continued to shepherd their people away from the God of Abraham. They lost sight of the law and their covenant with the Lord. Their disobedience was met with strife for their people. Asa tried to guide his people back to the path of righteousness. He was reform-minded and did much to eliminate idolatry. His long reign of forty-one years was rewarded with peace and prosperity.

His son Jehoshaphat continued his work. His reign lasted twenty-five years and was considered the most prosperous since King Solomon. Like his father, Jehoshaphat was a moral teacher and sent Levites among the people to teach the law of the Lord.

Jehoram was not to continue in the tradition of his father and grandfather. He married the daughter of Ahab, the king of Israel, and returned to the worship of Baal. Edom and Libnah revolted against his rule, and the people of Judah were once again at war. This was the time of the prophet Elijah. Elijah wrote Jehoram a letter imploring him to change his ways.

The older man in the left side of this lunette might be Elijah rather than one of the kings listed on the plaque. He told of horrible things that would happen if Jehoram did not return to the Lord. Elijah wrote, "See, the Lord will bring a great plague on your people, your children, your wives, and all your possessions, and you yourself will have a severe sickness with a disease of your bowels, until your bowels come out, day after day, because of the disease" (2 Chr 21:14–15). But Jehoram did not follow Elijah's advice and all that the prophet wrote came true.

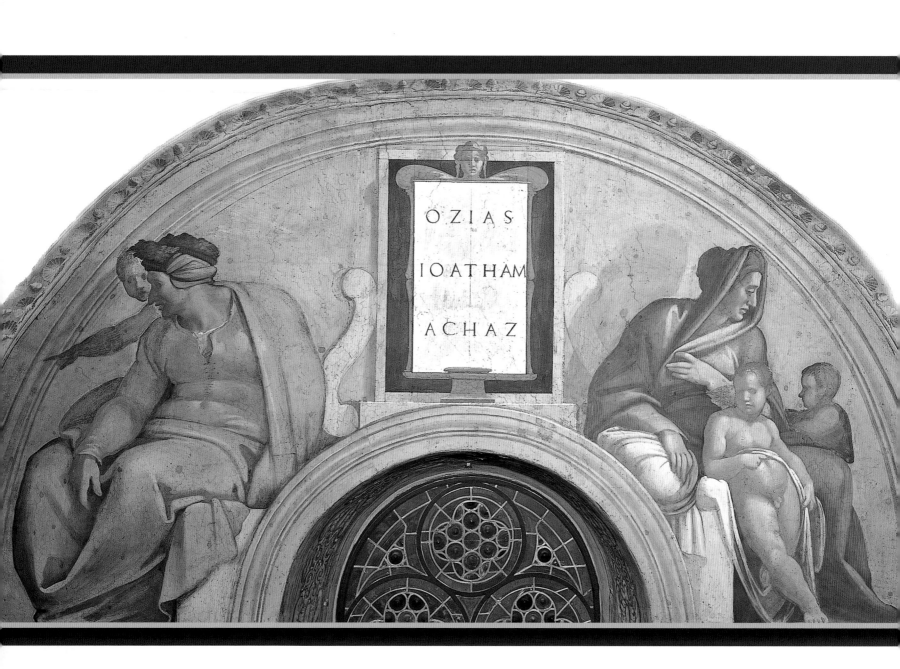

OZIAS

IOATHAM

ACHAZ

Uzziah, Jotham, and Ahaz

[Uzziah] set himself to seek God in the days of Zechariah, who instructed him in the fear of God; and as long as he sought the Lord, God made him prosper . . . [Jotham succeeded Uzziah.] Jotham became strong because he ordered his ways before the Lord his God . . . [His son] Ahaz was twenty years old when he began to reign . . . He did not do what was right in the sight of the Lord . . . Therefore the Lord his God gave him into the hand of the king of Aram, who defeated him and took captive of a great number of his people and brought them to Damascus.

—2 Chronicles 26:5; 27:6; 28:1, 5

Uzziah attempted to follow the covenant with the Lord and his reign was a time of prosperity. It was unprecedented for a nation to experience fifty-two years of peace and that is what his righteousness brought his people. But Uzziah became too self-confident and wanted to offer incense at the altar of the Lord, a task given only to the descendents of Aaron. For his sin of pride, Uzziah was struck with leprosy while standing at the altar, and his kingdom went to his son Jotham. Jotham continued to keep the covenant with the Lord and his kingdom continued to prosper. His son, Ahaz, was not to follow the family tradition of piety and respect for the Lord.

Ahaz was a wicked man who worshiped idols. He offered one of his sons to Molech the fire god. Ahaz's behavior brought the wrath of God on his people. They were defeated in war and carried off as captives.

The behavior of the kings had serious repercussions for their people. When they were righteous and walked with the Lord, their people experienced peace and prospered. When they were wicked and forsook the Lord, their people were slaughtered and the nation was plundered. The nation reaped the consequences of the behavior of their kings. Jesus would do just the opposite. As King, he died to redeem us from sin.

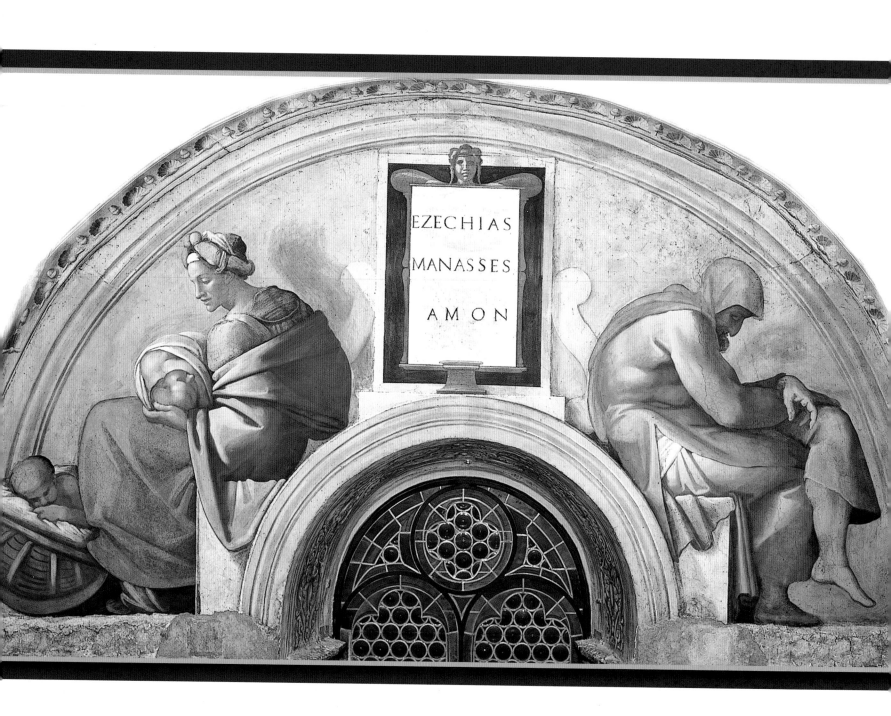

EZECHIAS
MANASSES
AMON

HEZEKIAH, MANASSEH, AND AMON

[Hezekiah] trusted in the Lord the God of Israel; so that there was no one like him among all the kings of Judah after him, or among those who were before him . . . [Manasseh] did what was evil in the sight of the Lord, following the abominable practices of the nations that the Lord drove out before the people of Israel . . . [Amon] walked in all the way in which his father walked . . . he abandoned the Lord, the God of his ancestors, and did not walk in the way of the Lord.

—2 Kings 18:5; 21:2, 20–22

In great distress, King Hezekiah prayed to the Lord for healing, and then asked the prophet Isaiah for a sign that his prayer was heard. At his request the shadow of the sun went back ten steps as a sign from God.

His son Manasseh did not follow in his father's footsteps and went much further in his wickedness than other kings. In addition to promoting idolatry, he persecuted those who stayed faithful to the Lord. For his sins, he was taken captive by the king of Assyria and brought to Babylon as a prisoner. Manasseh had a change of heart while in prison. He humbled himself before God and was restored to Jerusalem and to his kingdom.

When his son Amon became king, he returned to idolatry. His servants conspired against him and killed him. The people then slew all who had conspired against Amon and made his son, Josiah, king.

The figure on the right is sometimes thought to represent Manasseh. He is crushed by the weight of his sins against God and his people. The color purple represents penance and is used in altar cloths and priest's vestments during Lent. Manasseh wears a hooded cloak of purple that represents his need to repent for his sins, his need to do penance.

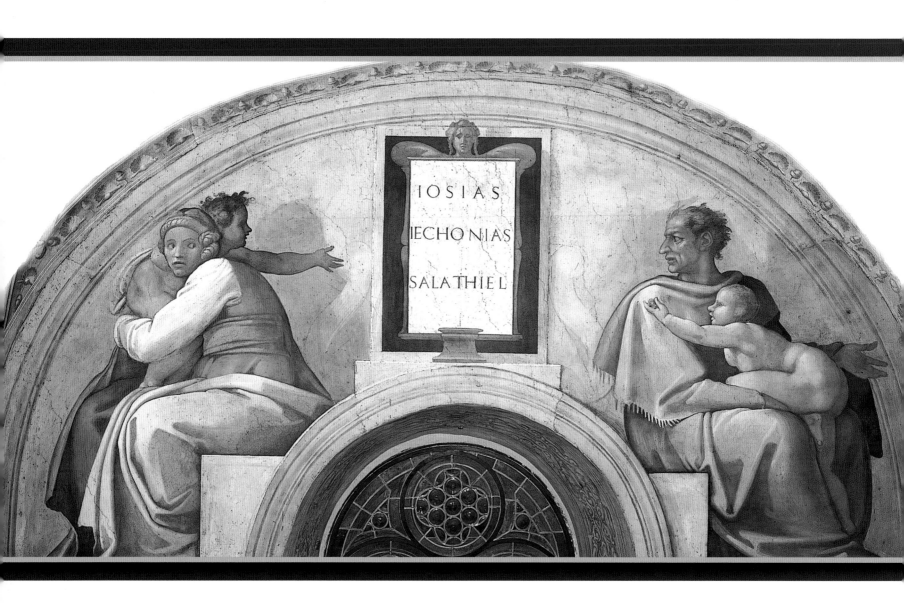

JOSIAH, JECHONIAH, AND SHEALTIEL

[Josiah] did what was right in the sight of the Lord, and walked in all the way of his father David; he did not turn aside to the right or to the left . . . The king stood by the pillar and made a covenant before the Lord, to follow the Lord, keeping his commandments, his decrees, and his statutes, with all his heart and all his soul, to perform the words of this covenant that were written in this book. All the people joined in the covenant . . . Before him there was no king like him who turned to the Lord with all his heart, with all his soul, and with all his might, according to all the law of Moses; nor did any like him arise after him.

—2 Kings 22:2; 23:3, 25

Josiah was the last king who attempted to reform the people of Judah before the Babylonian Captivity. While doing an inventory of the temple, the high priest Hilkiah found the Book of the Law. Josiah understood the misfortunes that had befallen Judah were the results of the kings and people turning away from their covenant with God. The book inspirited him and set him about the business of returning his people to the house of the Lord. He tore down places of idol worship and destroyed the objects used in worshiping false gods. He eliminated mediums, wizards, and other abominations. He attempted to establish the words of the Book of the Law in the land. Josiah worked with the prophet Jeremiah to restore the temple. His reform efforts and his reign lasted thirty-one years.

Josiah's reforms did not continue and his sons, Jechoniah and Jehoiakim, returned to the evil ways of their ancestors. It was during this time that Jerusalem was destroyed, and all the people were taken as captives to Babylon. Jeremiah's prophecy had come true. The Babylonian captivity was to last seventy years.

Shealtiel was the father of Zerubbabel, who was a leader in bringing the Israelites back to Jerusalem. Given the average life expectancy at that time, no one who lived in Jerusalem at the time the captivity began would be expected to return. The genealogy of Christ becomes difficult to follow at this point.

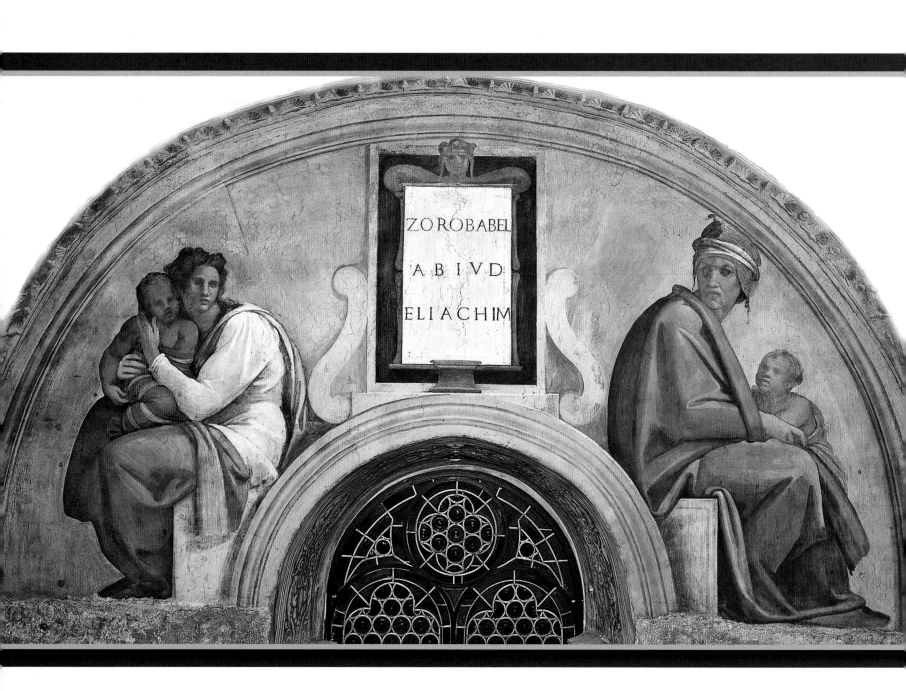

ZOROBABEL

ABIVD

ELIACHIM

Zerubbabel, Abiud, and Eliakim

"Thus says King Cyrus of Persia: The Lord, the God of heaven, has given me all the kingdoms of the earth, and he has charged me to build him a house at Jerusalem in Judah . . . Zerubbabel son of Shealtiel with his kin set out to build the altar of the God of Israel, to offer burnt-offerings on it, as prescribed in the law of Moses the man of God.

—Ezra 1:2; 3:2

Shealtiel was born during the Babylonian Captivity and so was his son, Zerubbabel, who was known as the Prince of Captivity. He was a leader among the people of Judah, but he also may have been in the service of King Cyrus.

When we read about captivity, we tend to think of imprisonment. But the people of Judah were not held in jail for seventy years. They continued their lives as farmers and tradesmen and civil servants. Some became very prosperous and their numbers increased. They left Babylon as an assembly of 42,360, with 7,337 servants and two hundred singers. They had 736 horses, 245 mules, 435 camels, and 6,720 donkeys (Ezra 2:64–67). So they left Babylon with a great number of people and considerable resources with which to rebuild Jerusalem and the temple.

It was Zerubbabel who laid the foundation of the temple and faced the daunting task of rebuilding. But he was given the message: "Not by an army or by might, but by my spirit says the Lord" (Zech 4:6). He was also told, "The hands of Zerubbabel have laid the foundations of this house and shall also finish it" (Zech 4:9). It took sixteen years to complete the temple.

It is impossible to relate the figures in this lunette to any of the people named in the plaque. It is a good example of Michelangelo's representation of the family of man rather than a particular family.

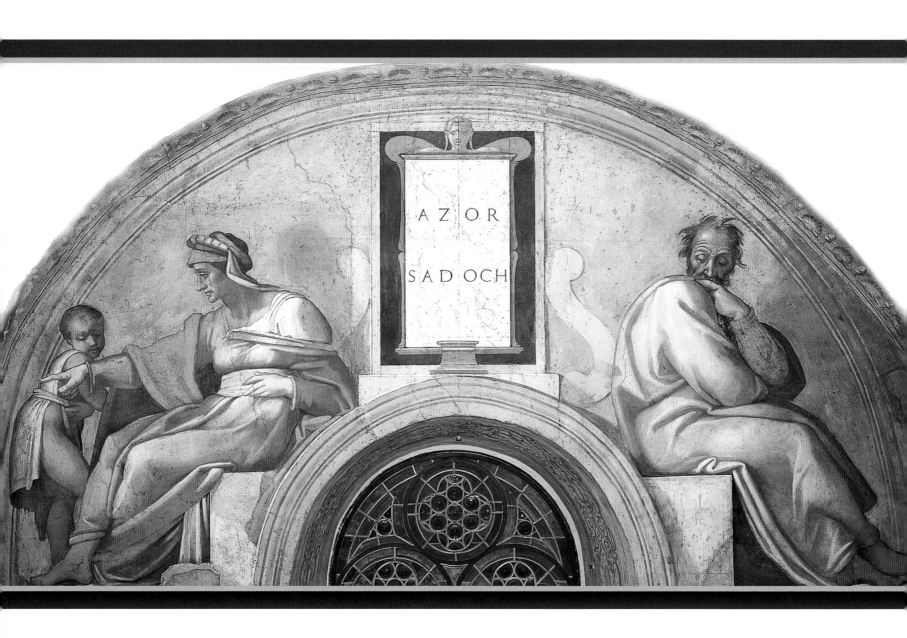

AZOR

SADOCH

AZOR AND ZADOK

After the deportation to Babylon: Jechoniah was the father of Shealtiel, and Shealtiel the father of Zerubbabel, and Zerubbabel the father of Abiud, and Abiud the father of Eliakim, and Eliakim the father of Azor, and Azor the father of Zadok.

— Matthew 1:12–14

There are no scriptural references to Azor or Zadok aside from Matthew's genealogy of Christ. There are several Zadoks in the Bible, but they are from different time periods. For example, a high priest in the time of David was named Zadok. Clearly, that man could not have been the father of Achim so many years later.

Given the lack of information regarding Azor and Zadok, it is impossible to attribute any significance to the figures in the lunette. It has been hypothesized that the man is another self-portrait of Michelangelo. The man is brooding and disheveled and certainly represents the popular image of the artist.

Michelangelo's portraits of Christ's ancestors represent the family of man rather than exact likenesses of his real ancestors. As such, this lunette is a good representation of most marriages during the Renaissance. Marriages were contracted to further political alliances and business relationships, not for love. The concept of romantic love as the basis of marriage would have seemed very strange to Michelangelo. The woman is engaged with her child, but not her husband. Men waited until they were in their thirties to marry so that they would have the ability to support a wife and family. Women married in their teens when their beauty and reproductive capacity were at their peak. Given the reasons for marriage and the differences in age between husbands and wives, it is not surprising that they had little in common and little reason for interacting beyond the business of maintaining a family.

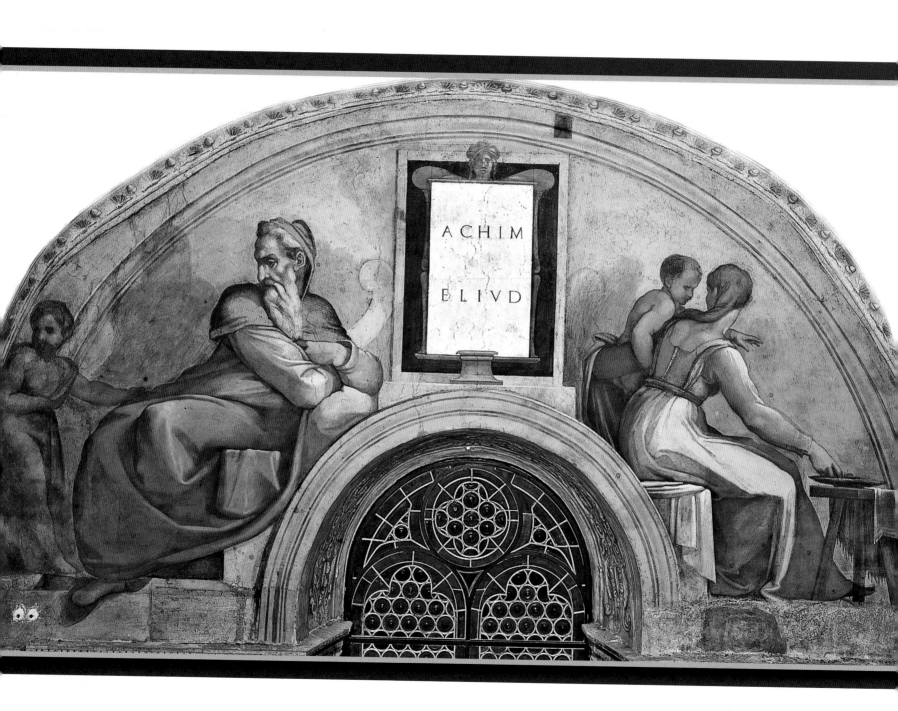

ACHIM AND ELIUD

Zadok [became] the father of Achim, and Achim the father of Eliud.

—Matthew 1:14

Once again there are no scriptural references to Achim or Eliud other than the genealogy of Matthew. The closer we get to Christ, the less we know about his ancestors. Apparently neither Achim nor Eliud did anything remarkable enough to warrant recording in the Old Testament. The noble line of kings from which Jesus descended had become very humble. His distant ancestors were patriarchs and kings, but the lives of his most recent ancestors were not remembered in scripture.

We know nothing about Achim and Eliud, so it is difficult to attribute significance to the figures in this lunette.

The man on the left appears to be settled into his position as if lost in thought. He does not look as if he will be moving soon. This is in contrast to the mother and child on the right. The child grabs the mother's left arm as the mother reaches for food with her right hand. These figures might represent the contemplative and active life styles. The virtue of the contemplative versus active life was hotly debated during the Renaissance. The ideal life found a balance between the two. The discussion of contemplative and active lives found expression in many works of art. Michelangelo visited this theme many years later when he sculpted Rachel and Leah for the tomb of Pope Julius II, the pope who commissioned the painting in the Sistine chapel.

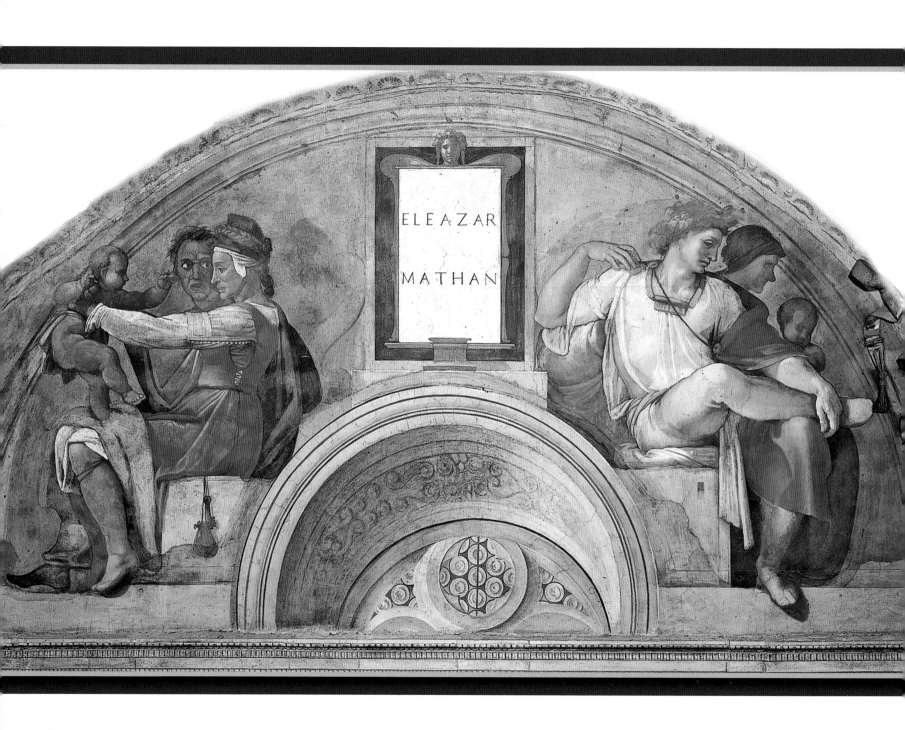

ELEAZAR

MATHAN

ELEAZAR AND MATTHAN

Eliud [became] the father of Eleazar, and Eleazar [became] the father of Matthan.

—Matthew 1:15

The name Eleazar appears several times in the Bible. The son of Aaron, Moses' brother was Eleazar and so was a warrior in David's army. But as in the case of Zadok, these men appeared centuries before this generation came to be. There is no mention in scripture of Eleazar the ancestor of Christ other than in the genealogy of Matthew. Thus, it is once again impossible to determine whom the figures in this lunette represent or the significance of their poses.

The young man on the right resembles the *ignudi* that flank the scenes from the Book of Genesis on the central spine of the ceiling. Michelangelo had no scripture on which to base his figures, so he may have simply returned to one of his favorite subjects, the male adolescent.

The child held on his mother's knees is less realistic, less lifelike than most of the figures on the ceiling. He looks more like the *putti*, or small wingless angels, that are part of the marble thrones on which the prophets and sibyls sit. In short, he resembles a statue rather than a baby. It is thought that this lunette was one of the first painted by Michelangelo. He protested this assignment and stated that painting was not his art. In fact, he sometimes included "sculptor" as part of his signature. Including two figures in this lunette that resemble sculpture might have been a subtle protest against Pope Julius II for forcing him to undertake this work.

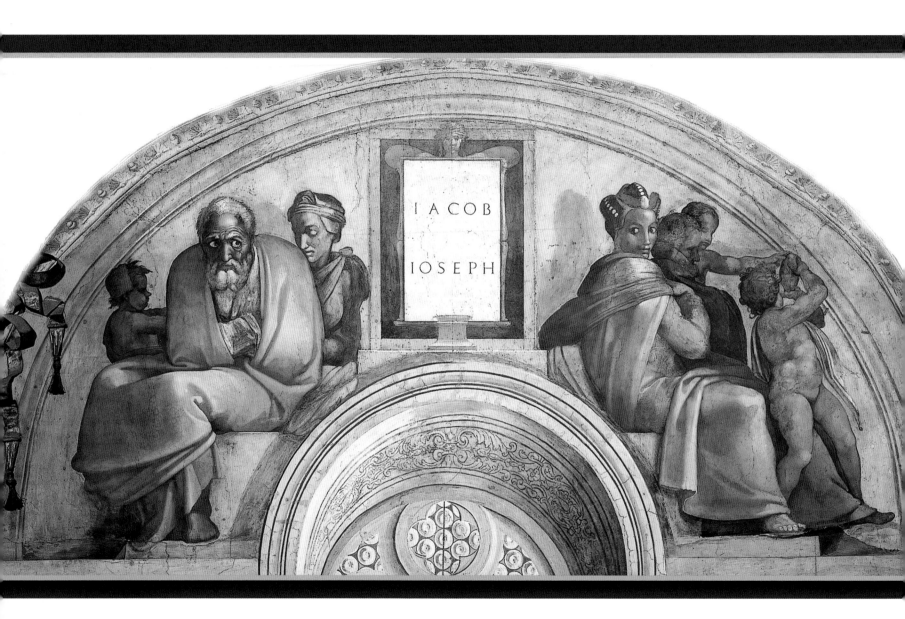

JACOB AND JOSEPH

Now the birth of Jesus the Messiah took place in this way. When his mother Mary had been engaged to Joseph, but before they lived together, she was found to be with child from the Holy Spirit. Her husband Joseph, being a righteous man and unwilling to expose her to public disgrace, planned to dismiss her quietly. But just when he had resolved to do this, an angel of the Lord appeared to him in a dream and said, "Joseph, son of David, do not be afraid to take Mary as your wife, for the child conceived in her is from the Holy Spirit. She will bear a son, and you are to name him Jesus, for he will save his people from their sins."

—Matthew 1:18–21

There is very little mention of Joseph in the New Testament even though he plays an important role in the birth and early childhood of Jesus. He listens to angels and follows their lead to keep Mary and Jesus safe. He takes the family to Egypt to avoid the slaughter of the innocents by King Herod. Joseph brings them back to Nazareth twelve years later for Jesus to begin his life in Israel. And then we hear no more about him. Tradition holds that he was considerably older than Mary, and it is assumed that he died before Jesus began his public life.

Joseph is seen in this lunette huddled in a yellow cloak. He looks very worried and fearful. That was a common way Joseph was portrayed in Renaissance paintings. He was an older man who had just married a pregnant woman. Angels were giving him messages, kings were visiting his new born son, and another king was determined to put the child to death. He was justified in being so concerned, and this painting reflects his emotions.

The female child standing in front of Mary carries a white cloth, another common icon in Renaissance painting that represented the shroud that the new born child would wear. This lunette completes the theological plan of the Sistine Chapel.

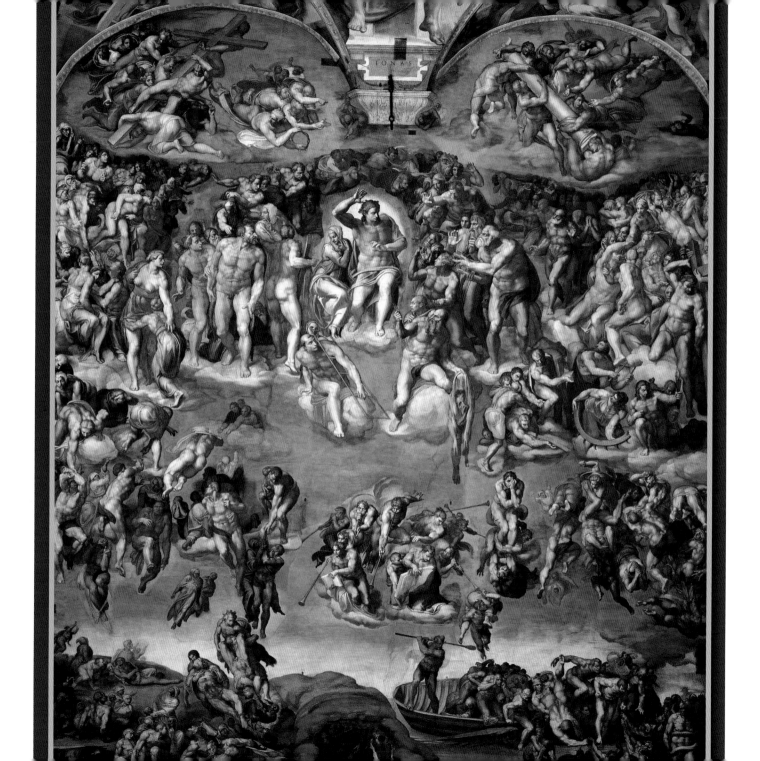

THE LAST JUDGMENT

*M*ichelangelo began work on *The Last Judgment* on the altar wall of the Sistine Chapel in 1536, twenty-eight years after he finished the ceiling. He had no idea that he would be working in this chapel as an old man, for sixty-one was certainly an old man at the time of the Renaissance. *The Last Judgment* would fill the entire altar wall and would be the image that worshipers would contemplate during Mass. In order to complete the monumental work, he needed to remove two of his own frescoes depicting Abraham and his descendants that were included in his earlier work on the ceiling. He also removed three frescoes by Perugino that began the fresco cycle that circles the walls of the chapel and describes the lives of Moses and Christ. Michelangelo wanted *The Last Judgment* to loom over the viewer and reconstructed the wall so that the top overhangs the bottom by over eleven inches.

Viewing *The Last Judgment* can be overwhelming. It is easier to understand if we divide it into four horizontal quadrants. The top quadrant is filled with angels holding reminders of Christ's crucifixion. Angels hold a crown of thorns and other instruments of torture as reminders of how Christ suffered for our redemption. A colossal Christ is pictured in the second quadrant separating the damned from the saved. His mother is seated next to him and the saints who are already in heaven flank him. It is thought that Michelangelo used Vittoria Colonna, the woman he loved most, as the model for the Virgin. Many of the saints can be identified by their attributes. For example, St. Peter is pictured with the keys to the king-

dom. St. Bartholomew was flayed alive and he is portrayed with his skin. (Michelangelo "signed" this fresco by painting a self-portrait on that skin.) Angels and saints lift the saved heavenward in the third quadrant. One soul is helped towards heaven with a rosary that symbolizes the help of the Catholic Church. The damned are painted being dragged to hell by all sorts of fearsome creatures as well as by the weight of their sins. The fourth quadrant portrays souls emerging from their graves, some to be carried up to heaven and some to be ferried to hell.

The Last Judgment was completed in 1541. It was the time of the Protestant Reformation, when Luther, Zwingli, and Henry VIII, with the help of the new printing press, caused serious problems for the Catholic Church. Pope Paul III tried to reform the Church in what came to be called the Counter Reformation. Driven by the spirit to make amends for the excesses of many Renaissance popes, some reformers looked at *The Last Judgment* in horror. They felt that the nudes, once considered to be the highest expression of beauty, belonged in a bath or brothel. Zealous reformers hired Daniele da Volterra to correct the situation. His work earned him the nickname Il Brahettone, or pants-maker, for the loincloths he painted over the offensive body parts. Later restorations removed some of da Volterra's pants, but many remain.

"When the Son of Man comes in his glory, and all the angels with him, then he will sit on the throne of his glory. All the nations will be gathered before him, and he will separate people one from another as a shepherd separates the sheep from the goats, and he will put the sheep at his right hand and the goats at the left." (Matt 25:31–33)

"Come, you that are blessed by my Father, inherit the kingdom prepared for you from the foundation of the world. Then he will say to those at his left hand, 'You that are accursed, depart from me into the eternal fire prepared for the devil and his angels.'" (Matt 25:34–41)

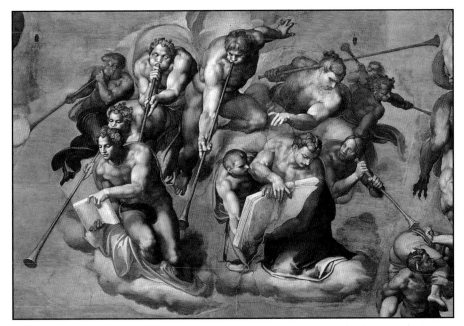

Michelangelo's *The Last Judgment*, 1536–1541, Sistine Chapel, Vatican, Rome.

Now the seven angels who had the seven trumpets made ready to blow them. (Rev 8:6)

Also another book was opened, the book of life. And the dead were judged according to their works, as recorded in the books. (Rev 20:12)

And anyone whose name was not found written in the book of life was thrown into the lake of fire. (Rev 20:15)

What profit is there in my death, if I go down to the Pit? (Ps 30:9)

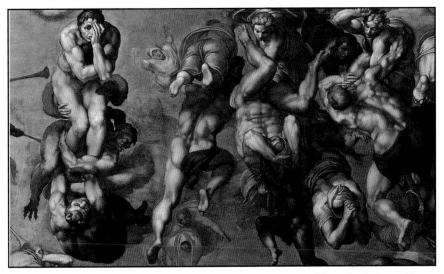

Michelangelo's *The Last Judgment*, 1536–1541, Sistine Chapel, Vatican, Rome.

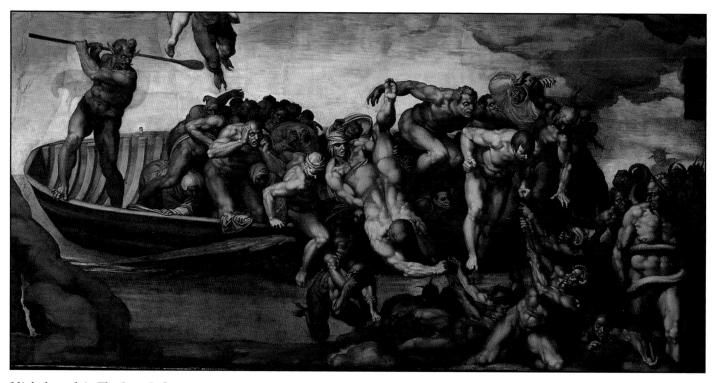

Michelangelo's *The Last Judgment*, 1536–1541, Sistine Chapel, Vatican, Rome.

Death shall be their shepherd;
straight to the grave they
descend. (Ps 49:14)

"Amen! Blessing and glory and
wisdom
and thanksgiving and honor
and power and might
be to our God forever and ever!
Amen." (Rev 7:11–12)

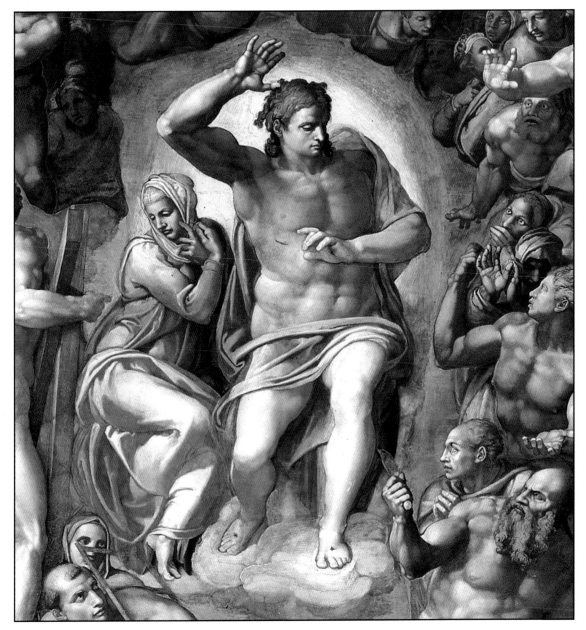

Michelangelo's *The Last Judgment*, 1536–1541, Sistine Chapel, Vatican, Rome.

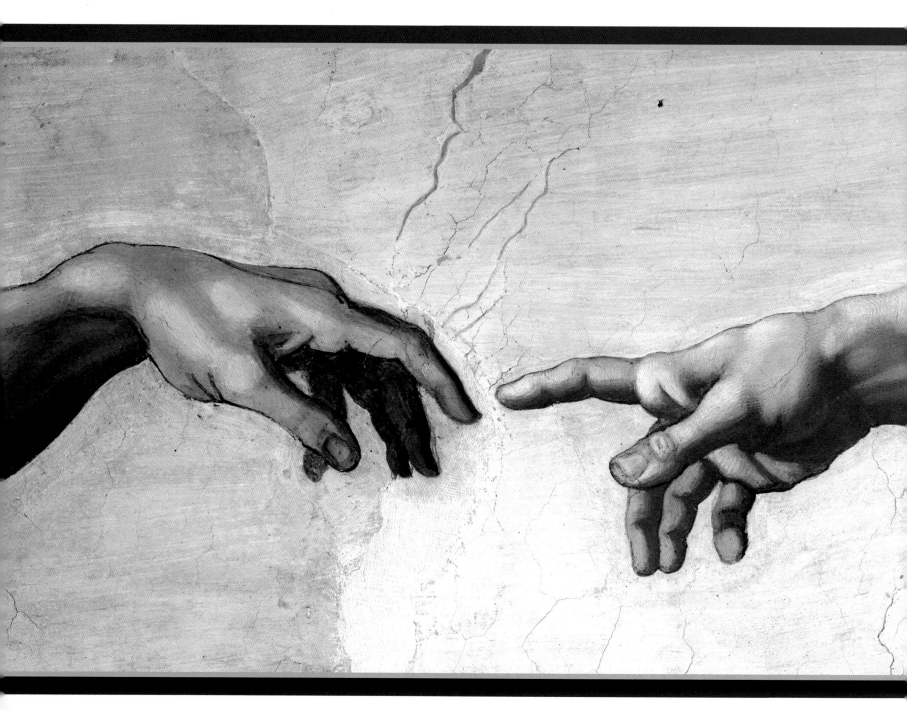

CONCLUSION

A voice cries out:
"In the desert prepare the way of the Lord,
make straight in the desert a highway for our God!"

—Isaiah 40:3

Michelangelo's ceiling in the Sistine Chapel has become that "highway for our God." We can use this most glorious collection of Renaissance paintings as a highway for our own spiritual journey. Michelangelo took us from the beginning of time, through the creation of man. He introduced us to the prophets sent to guide God's people. He told us of the stories of God's saving grace and of man's refusal to accept it. Michelangelo led us from the sins of man to salvation through the Cross and Jesus Christ.

Millions of visitors have walked beneath Michelangelo's ceiling in the past five hundred years. It has had a greater impact on our world than even a man of Michelangelo's genius could have anticipated. Each visitor has taken something different from the experience.

Some have been awed by the accomplishment of one man. Others are overwhelmed by the grandeur of the work. Some hurry through eager to get to the next stop on their tour. Some, no doubt, have been moved to examine their own spiritual life. Contemplating Michelangelo's work with the scripture on which it was based deepens out understanding of both. Scripture provides the foundation for the paintings and the paintings illuminate the scripture. This book is a "thank you" to Michelangelo for providing the world with this inspirational "highway for our God."

WORKS CONSULTED

De Vecchi, Pierluigi, and Gianluigi Colalucci. *Michelangelo: The Vatican Frescoes*. New York: Abbeville, 1997.

Gallico, Sonia. *The Sistine Chapel: A Visit through Images*. Vatican: ARS Italia Editrice, 2002.

Holy Bible: New Revised Standard Version with the Apocrypha. New York: Oxford University Press, 1989.

King, Ross. *Michelangelo and the Pope's Ceiling*. New York: Penguin Books, 2003.

Kloss, William. *Great Artists of the Italian Renaissance*. Chantilly, VA: The Teaching Company, 2004.

Lopes, Antonino. *The Popes: The Lives of the Pontiffs through 2000 Years of History*. Rome: Futura Edizioni, 1997.

Smith, William. *A Dictionary of the Bible*. Revised and edited by F. N. and M. A. Peloubet. Nashville: Thomas Nelson, 1986.

Symonds, John Addington. *The Life of Michelangelo Buonarroti*. Philadelphia: University of Pennsylvania Press, 2002. Originally published by J. C. Nimmo and Charles Scribner's Sons, 1911.

Vasari, Giorgio. *The Lives of the Artists*. Translated by Julia Conaway Bondanella and Petter Bondanella. Oxford: Oxford University Press, 1991.

Wallace, William E. "Michelangelo's Assistants in the Sistine Chapel." *Gazette des Beaux-Arts II* (December 1987): 203–16.

———. *Michelangelo: The Complete Sculpture, Painting, Architecture*. New York: High Lauter Levin Associates, Inc., 1998.